BRITISH POSTERS OF THE SECOND WORLD WAR

RICHARD SLOCOMBE

The author would like to give special thanks to Naomi Games, Pat Schleger, Jane Rabagliati, Marion Wesel-Henrion, Michael Le Witt, Gary Nachshen, Steve Thomas and James Aulich for their very generous advice, assistance and provision of images.

Thanks too to my colleagues Madeleine James, Rebecca Hunter, Terry Charman and Liz Bowers for support, input and advice.

IWM (Imperial War Museums) holds over 20,000 posters in its collections, dating from the
First World War to the present day. For more information visit iwm.org.uk.

Published by IWM, Lambeth Road, London SE1 6HZ
iwm.org.uk

ISBN 978-1-904897-92-7
A catalogue record for this book is available from the British Library.
Printed by Graphicom SrL

CONTENTS

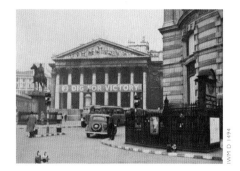

LEFT A view of the Royal Exchange in London, 1940, which was used as a Ministry of Information 'special poster site'.

BELOW A row of Ministry of Information posters, 1942

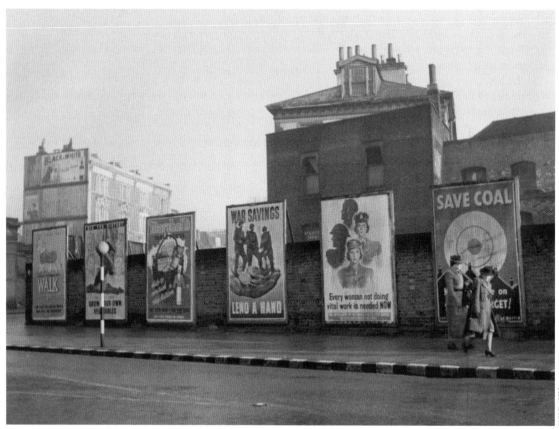

INTRODUCTION

The Second World War for Britain meant 'total war', with the whole of the population to a greater or lesser extent affected. Britain's island status, for so long its defence, was battered by the bomber and blockaded by the U-boat. Under unprecedented pressure, the British public were called upon to show great stoicism and forced to accept stringent measures – such as rationing and the blackout – to survive. As Lloyd George had feared in the First World War, 'if the home front breaks, then everything breaks'.

To ensure that the home front did indeed survive, the British government mounted a determined propaganda campaign to maintain the spirit and well-being of the people and to impress upon them austere but vital policies. The slogans that characterised these propaganda campaigns, such as 'Dig for Victory', 'Be Like Dad, Keep Mum' and 'Coughs and Sneezes Spread Diseases' have since become legendary, entering the national consciousness and remaining common parlance to this day.

Chiefly responsible for imparting these messages were, of course, posters. Fondly recalled for their common touch and breezy catchphrases, it is often difficult to conceive of these iconic images as propaganda. Yet Britain's posters were remarkable for their sophisticated communication and proficient design. They demonstrated that propaganda need not be aggressive or artistically conservative to engage a wide audience, but that subtle humour and Modernist design could be just as persuasive and popular.

Posters were produced by government ministries, charities, and public and private concerns. These organisations were often headed by enlightened ministers and publicity managers who drew upon a rich pool of designers, cartoonists, illustrators and artists. British war propaganda provided opportunities for progressive young designers at the threshold of their careers, such as Abram Games, Tom Eckersley and Reginald Mount. It also enabled many non-British artists, some of them refugees from enemy countries, to contribute to the most enduringly popular imagery of wartime Britain.

For some artists the Second World War meant a brief sojourn into poster design, returning to former careers as illustrators, cartoonists or fine artists as soon as peace allowed. But for others, the war was the making of their careers. Second World War propaganda gained British graphic design an international reputation in the post-war decades. Though the designers themselves would never become household names, their posters, publicity and corporate logos remain with us today and continue to be admired.

Britain's distinctive approach to propaganda and poster art during the Second World War was not simply luck at having so many talented designers

A prospective recruit is attracted
by a Ministry of Information poster

and propagandists present at one time – the country's first foray into mass persuasion in the First World War was heavily influential.

During that conflict Britain had led the way in developing propaganda, utilising the poster to raise its first mass army. The government had at first refused to introduce conscription, hoping that the inherent patriotism of the British male would be enough to encourage them to join up voluntarily. But as the conflict dragged on, the need for more soldiers became acute and the government implemented the first serious propaganda campaign of the war. Early posters merely issued a simple call to arms for the sake of King and country, but as the war continued, posters adopted increasingly manipulative methods of securing enlistment. Emotional blackmail, not just of potential recruits, but of wives, girlfriends and parents, was commonplace, resulting in such notorious copy as *Daddy, What Did YOU Do in the Great War?*

The British government's sanctioning of such emotional manipulation eroded the respect of many serving on the front, and led to a growing resentment among the troops towards those at home. This ill-feeling was increased by public ignorance of the trenches, thanks in part to the exaggerated tales of British heroism and German atrocities in the newspapers.

Cynicism in wartime did remain largely confined to the frontlines, but in peace the nation's wholehearted embrace of mass propaganda was to many disquieting and at odds with the supposedly liberal British consciousness. This use of publicity during the First World War, and the accompanying backlash towards atrocity propaganda in particular, caused an enduring suspicion of propaganda in both British government and society that would persist throughout the inter-war years.

Others, however, took a different view. Adolf Hitler wrote admiringly of British propaganda in *Mein Kampf*. To him, it was 'as brilliant as it was terrible'. Hitler's accession to the German Chancellorship in 1933 enabled the formation of a Ministry of Propaganda, under Josef Goebbels, who began a vast campaign of indoctrination. Within this unrelenting programme of radio broadcasts, cinema, parades and rallies, there was still a role for the poster. Acting as a constant daily reminder of the state's presence, it expressed Nazism's core beliefs. Posters of beaming Aryan families re-introduced the nationalist concept of the 'folk community', while vicious antisemitic and anti-Bolshevik caricatures gave the public figures to fear and hate.

Germany, once home to radical art and design movements such as Dadaism and the Bauhaus, now branded all Modernist expression as degenerate. Opinion elsewhere was also turning against the avant-garde. In 1934,

A poster warning of the dangers of venereal disease is pasted to a wall outside the Ministry of Health in Westminster, 1943

IWM D 13825

the Soviet dictator Joseph Stalin introduced mundane 'Socialist Realism' as the state art form, suppressing the plethora of artistic styles and attendant doctrines such as Constructivism and Suprematism that had characterised 1920s Russia. Many persecuted European artists therefore sought refuge in Britain, finding that the country – usually seen as artistically conservative – had actually grown more receptive to Modernism. British commercial advertising agencies like WS Crawford Ltd had embraced progressive Continental graphics via offices in Paris and Berlin. Home-grown poster artists such as Ashley Havinden and Austin Cooper were also emerging, and the new mood of Modernism was discussed in newly-founded design journals such as *Art and Industry*.

Elsewhere, gifted publicity managers like Frank Pick of London Transport and Jack Beddington of the oil company Shell-Mex capitalised on growing leisure travel and rising consumerism with dynamic poster campaigns by artists and designers such as Paul Nash. The success of these campaigns persuaded the government of the value of marketing. Under Sir Stephen Tallents, the Empire Marketing Board and then the General Post Office pioneered co-ordinated publicity campaigns involving film-makers, poets and poster artists.

Yet looming over this climate of design innovation and carefree consumption was

the prospect of conflict with Nazi Germany. Developments in bomber technology in the 1920s and 30s led many in Britain to fear that the next war would bring with it an unparalleled psychological dimension, owing to the deliberate targeting of civilians. Therefore, propaganda should and must play a central role in deciding its outcome. As early as 1935 plans had been drawn up for a body equivalent to that of Goebbels' Ministry of Propaganda. Competing with Germany's well-established propaganda machine was an onerous task in itself, made harder still by the lack of appetite for mass persuasion at the top of government. Harbouring memories of First World War propaganda and associations with the aggressive indoctrination of European dictatorships, Neville Chamberlain's government was reluctant to countenance propaganda lest it undermine British democracy.

The Ministry of Information that came into being at the declaration of war in 1939 was little short of disastrous. It would take two years and four ministers before it could at last begin to establish a distinctive public voice – one that reflected, contributed to and eventually grew to embody the notion that Britain's war was, indeed, the 'people's war'.

Richard Slocombe, Senior Curator
Department of Art

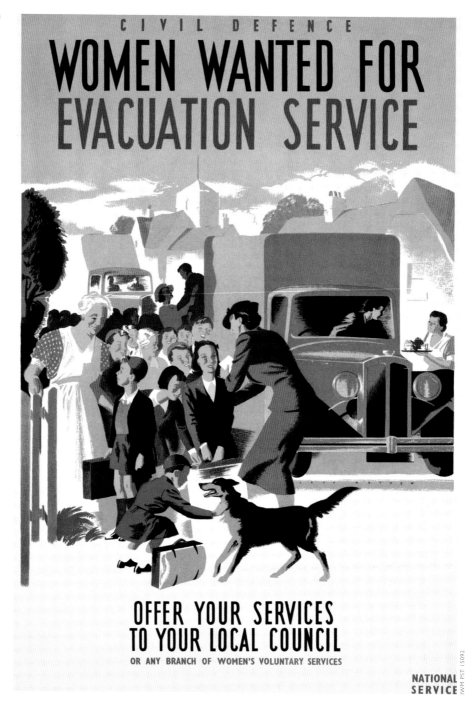

I. INSIPID INVOCATIONS

BRITAIN'S EARLY WARTIME POSTERS

During the Second World War the Ministry of Information (MOI) was largely responsible for Britain's home front propaganda effort. Preparations for such a ministry had begun as early as 1935 – the plan was to compete with Nazi Germany's highly efficient Ministry of Propaganda by promoting Britain's position both at home and abroad. The MOI duly came into being on 4 September 1939, the day after war was declared.

Initially the MOI's efforts were focussed on upholding the nation's morale, a policy arising from predictions of a German air onslaught at the outset of war. However, this was a task for which the Ministry was ill-prepared. Its officials, drawn largely from the civil service, knew nothing of publicity or psychology. Perceptions of the public were formed largely through class prejudice and it was assumed that the British people could simply be coerced into showing resolution.

With access to a range of media, MOI officials invested particular faith in posters to sustain morale. At the outbreak of war they mounted an expensive publicity campaign to rally the nation. Over a million simple text-based posters bearing the statements, *Your Courage, Your Cheerfulness, Your Resolution Will Bring Us Victory* and *Freedom is in Peril, Defend It with All Your Might* were expected to command 'immediate attention' and 'exert a calming influence'.[1]

Yet the campaign was an abject failure. *The Times*, capturing the general mood, derided the *Your Courage* poster as an 'insipid and patronising invocation'.[2]

To understand the failure of these early posters, in November 1939 the MOI commissioned the public survey organisation Mass Observation (MO) to audit opinion. Following interviews with 1,391 people throughout Britain, MO reached damning conclusions. It found that few people had actually noticed the posters. Of those who had, many were hard-pressed to recall their statements. Others felt disengaged by their lofty tone and abstract notions of 'Freedom' and 'Resolution'. Worst of all, many took exception to the divisive implication that their 'courage' should be applied to bring 'victory' to a minority ruling elite.

Prime Minister Neville Chamberlain's personal distrust of propaganda had been an additional hindrance to the MOI, but even Winston Churchill's succession in May 1940 made little difference. The MOI persisted with attempts at raising morale despite suspicions even among its own staff that such policies were ineffectual. Posters such as *Mightier Yet* and *Back Them Up* (page 7) were typical of its efforts to stiffen the public resolve through vague and condescending exhortations.

1. Quotation sourced in MacLaine, Ian: *Ministry of Morale: Home Front Morale and the Ministry of Information in World War II*, George Allen and Unwin (London) 1979, p.30
2. Quotation sourced in Yass, Marion: *This is Your War: Home Front Propaganda in the Second World War*, HMSO (London), 1983, p.6

With a message
of paternal
reassurance, this
poster was intended
to allay public
panic following the
predicted air raids at
the outset of war. In
the event, German
air attacks would
not come for another
ten months, and
the failure of *Keep
Calm*'s sister posters
(top right and bottom
left) ensured that no
copies of this now
famous poster were
ever distributed,
despite a print run
of over a million.

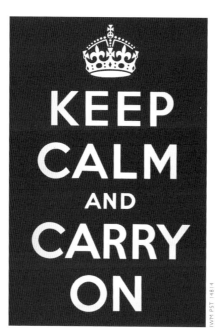

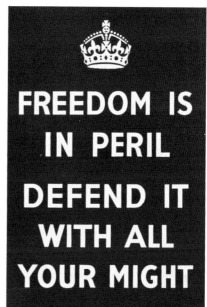

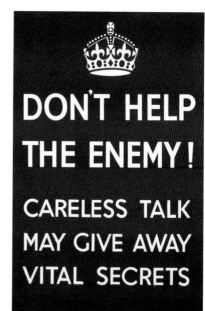

Every day more PLANES
Every day more PILOTS

IWM PST 14797

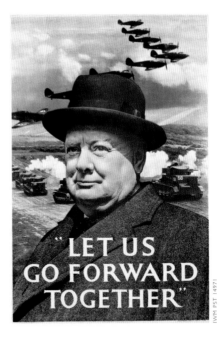

"LET US GO FORWARD TOGETHER"

IWM PST 14971

UNKNOWN
MIGHTIER YET! (1940)

UNKNOWN
LET US GO FORWARD
TOGETHER (1940)

Churchill, always the self-publicist, had few qualms about the use of his image for propaganda. This poster was intended to signal a more resolute and bellicose war effort following Churchill's accession to the office of Prime Minister. Its title was taken from his first speech as Prime Minister on 13 May 1940, 'Blood, toil, tears and sweat'.

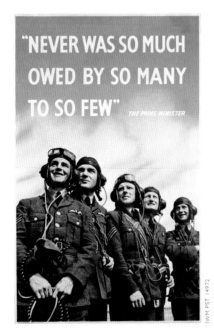

"NEVER WAS SO MUCH OWED BY SO MANY TO SO FEW" *THE PRIME MINISTER*

IWM PST 14972

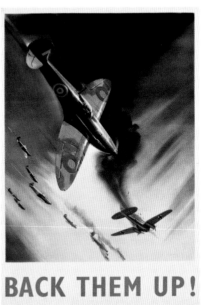

BACK THEM UP!

IWM PST 14799

UNKNOWN
NEVER WAS SO MUCH
OWED BY SO MANY
TO SO FEW (1940)

FRANK WOOTTON
(1914–1998)
BACK THEM UP! (1940)

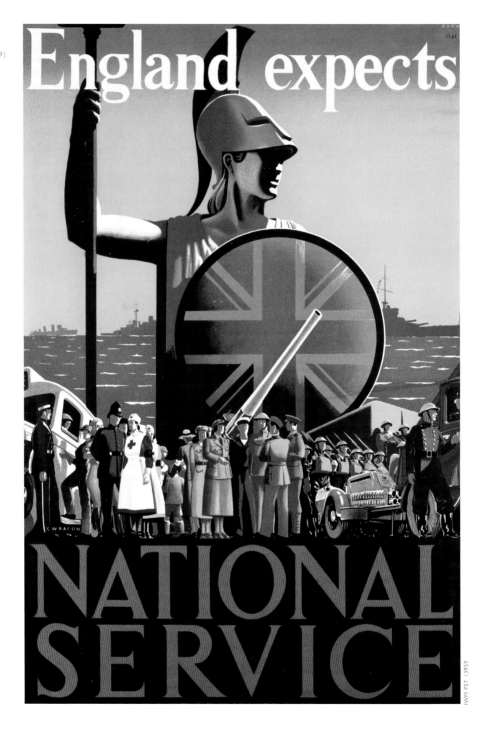

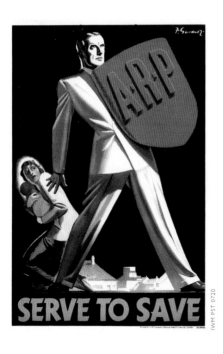

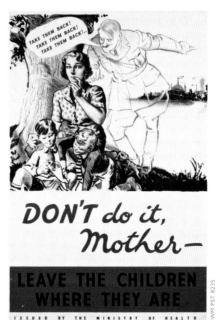

IWM PST 0720

IWM PST 8235

Early propaganda images of feminine fear and susceptibility reflected the British establishment's doubts over women's capacity to endure war. The experience of the Blitz and the need in 1941 for women to undertake war service inevitably forced a re-evaluation of outdated attitudes.

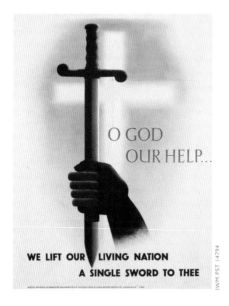

IWM PST 14794

Paraphrasing Isaac Watts' famous hymn, this poster conjured an essentially middle-class vision of religious devotion and knightly virtue. Such exhortations revived memories of discredited First World War propaganda and were quickly abandoned for more secular, populist approaches.

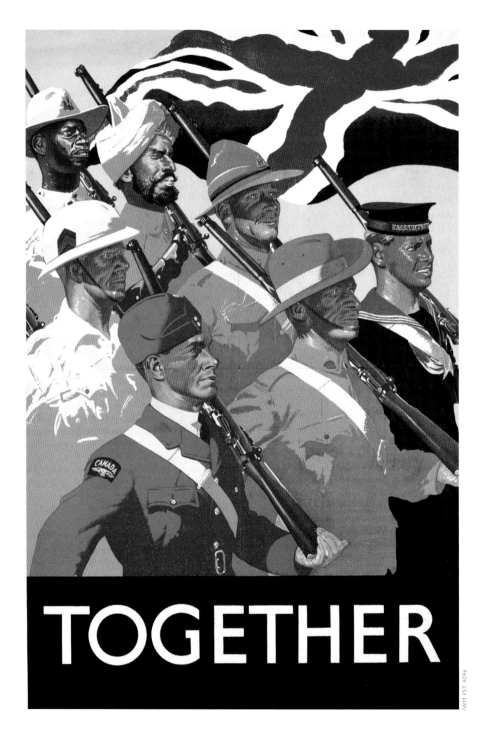

TOGETHER

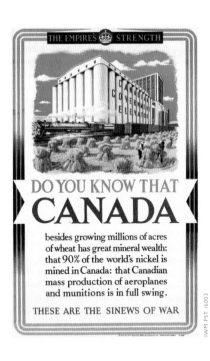

DO YOU KNOW THAT

CANADA

besides growing millions of acres
of wheat has great mineral wealth:
that 90% of the world's nickel is
mined in Canada: that Canadian
mass production of aeroplanes
and munitions is in full swing.

THESE ARE THE SINEWS OF WAR

IWM PST 16003

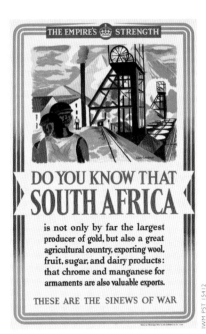

DO YOU KNOW THAT

SOUTH AFRICA

is not only by far the largest
producer of gold, but also a great
agricultural country, exporting wool,
fruit, sugar, and dairy products:
that chrome and manganese for
armaments are also valuable exports.

THESE ARE THE SINEWS OF WAR

IWM PST 15412

CECIL WALTER BACON
(1905–1992)
DID YOU KNOW THAT –
CANADA (C.1939–40)

CLIVE GARDINER
(1891–1960)
DID YOU KNOW THAT –
SOUTH AFRICA (C.1939–40)

HAROLD SANDYS
WILLIAMSON (1892–1978)
DID YOU KNOW THAT –
NEW ZEALAND (C.1939–40)

KEITH HENDERSON
(1883–1982)
DID YOU KNOW THAT –
AUSTRALIA (C.1939–40)

Reminiscent of the
pre-war Empire
Marketing Board's
'buy Empire' publicity
campaigns, these
posters attempted to
dispel public concerns
about Britain's
wartime isolation
with reassurances
of the breadth of the
Empire's resources.

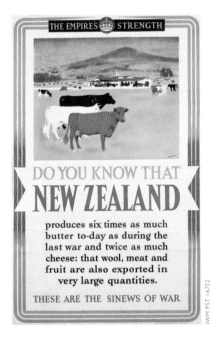

DO YOU KNOW THAT

NEW ZEALAND

produces six times as much
butter to-day as during the
last war and twice as much
cheese: that wool, meat and
fruit are also exported in
very large quantities.

THESE ARE THE SINEWS OF WAR

IWM PST 16752

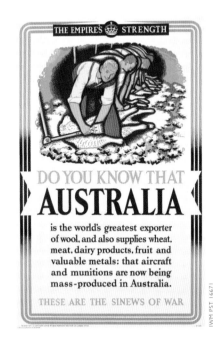

DO YOU KNOW THAT

AUSTRALIA

is the world's greatest exporter
of wool, and also supplies wheat,
meat, dairy products, fruit and
valuable metals: that aircraft
and munitions are now being
mass-produced in Australia.

THESE ARE THE SINEWS OF WAR

IWM PST 16671

HAROLD FORSTER
(ACTIVE 1930s–1950s)
KEEP MUM, SHE'S NOT
SO DUMB (1941)

Forster's 'careless talk' poster revealed the contradictory nature of British propaganda's representation of women, which, according to the needs of the day, lurched between clichéd sexual stereotypes to progressive expressions of female empowerment.

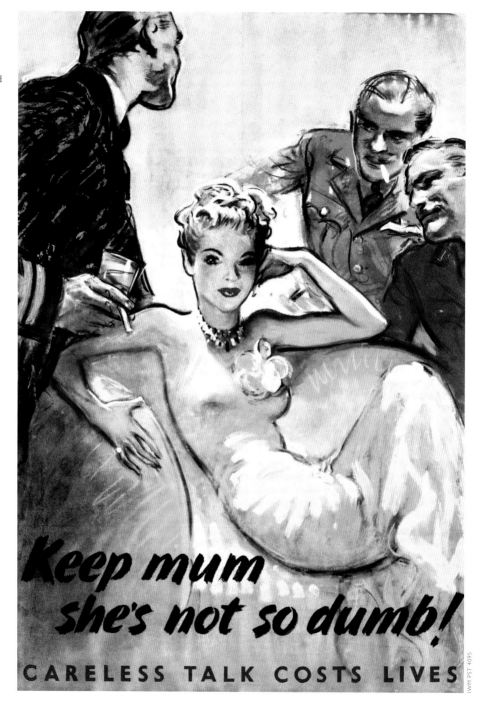

Keep mum
she's not so dumb!

CARELESS TALK COSTS LIVES

IWM PST 4095

2. CHEER US UP A BIT

NEW ATTITUDES AND APPROACHES
IN PROPAGANDA

Ironically, morale was low in the Ministry of Information (MOI) in 1940. Often ridiculed by other government departments, the Ministry was criticised in Parliament and in the press for lacking a coherent strategy. However, Winston Churchill's demands for 'anti-gossip material'[3] to combat espionage and the spread of rumours offered an opportunity for the MOI to act upon the harsh lessons of Mass Observation's (MO) 1939 survey (see page 5), which had revealed early campaigns to be out of touch and ineffectual.

To avoid repetition of earlier anti-rumour campaigns – which had merely caused fear and suspicion – the MOI adopted a lighter touch. At the suggestion of MO, new poster campaigns offered catchy slogans couched in colloquial language, such as *Keep it Dark* and *Be Like Dad – Keep Mum* (page 15). Most successful though were the *Careless Talk Costs Lives* posters (page 15) of the *Punch* cartoonist, 'Fougasse' (Cyril Kenneth Bird, 1887–1965). His cartoons of everyday occurrences of idle gossip overheard by Hitler and Hermann Goering made an instant connection with the public. They highlighted another of MO's findings – the fundamental importance of humour in keeping public morale up and generating a sense of collective involvement.

The National Service Act in December 1941 – obliging all unmarried women under 30 to join the forces or enter war production – also demanded fresh perspectives in British propaganda. The hackneyed depictions of feminine vulnerability of earlier posters gave way to recruiting images of women exhibiting traditionally masculine virtues of confidence and determination, befitting the male domains they were entering. Philip Zec's (1910–1983) *Women of Britain Come into the Factories* went further still, picturing war production not simply as a patriotic duty, but as a means of emancipation and empowerment.

The greatest change in Britain's attitude to propaganda came following the appointment of Brendan Bracken (1901–1958) as Minister of Information in July 1941. Despite having no ministerial experience, Bracken reversed a trend of ineffectual leadership and brought new cohesion to the MOI. Trusting the resolve of the British public, Bracken abandoned the policy of exhortation. Instead, noting that morale improved with the provision of information, he repurposed the MOI to act as a government publicity agent working on behalf of other ministries (such as the Ministry of Food) in support of their wartime initiatives.

3. MacLaine, Ian: *Ministry of Morale: Home Front Morale and the Ministry of Information in World War II*, George Allen and Unwin (London) 1979, p.81

ABRAM GAMES (1914–1996)
YOUR TALK MAY KILL YOUR
COMRADES (1942)

When directly
addressing servicemen,
British 'careless talk'
propaganda often
adopted more forceful
imagery. Unusually
for a British wartime
poster, this image
pictures the actual
deaths of soldiers as
a consequence of the
indiscretion of others.
For the loose-lipped
soldier, Games is
believed to have used
an image of himself.
With the deadly spiral
emanating from his
mouth the designer
devised an effective
means of highlighting
the dangers of
injudicious gossip.

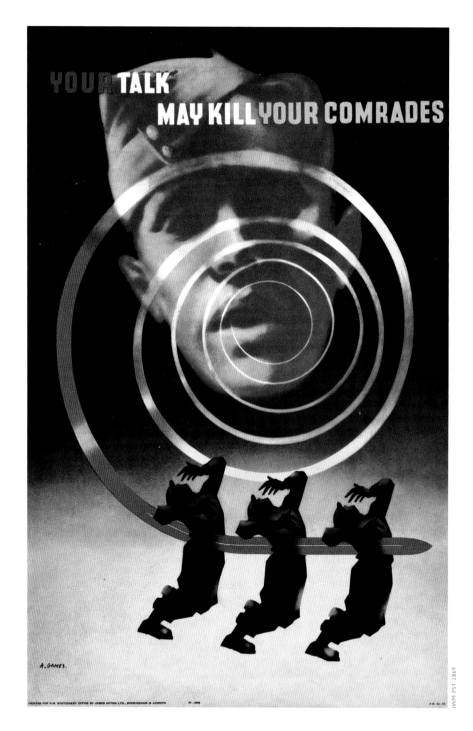

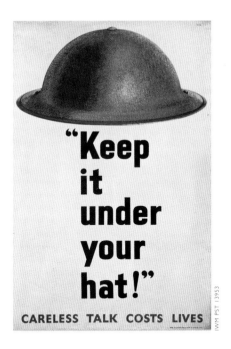

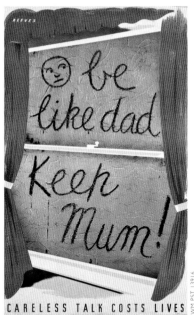

JOHN GILROY (1898–1985)
KEEP IT UNDER YOUR HAT!
CARELESS TALK COSTS
LIVES (1941)

REEVES (ACTIVE 1940s)
BE LIKE DAD – KEEP MUM
(1940)

Coined by Jack Beddington (the MOI Head of Films and a former publicist for Shell-Mex) *Be Like Dad – Keep Mum* exemplified Britain's distinctive public address during the Second World War. Memorable phrases using humour and popular slang lingered in the collective subconscious, and acted as a subtle and effective means of influencing behaviour.

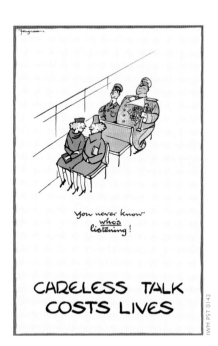

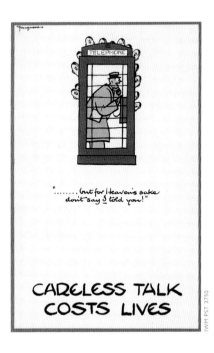

'FOUGASSE' (CYRIL
KENNETH BIRD, 1887–1965)
CARELESS TALK COSTS
LIVES (BOTH 1941)

Bird offered his services for free to the MOI, believing that humour could unite the British people and foster collective action. Conforming to a specific design format of a red border with a white background, Bird's comic vignettes introduced a key tenet of British wartime propaganda – the use of humour to impart a serious message.

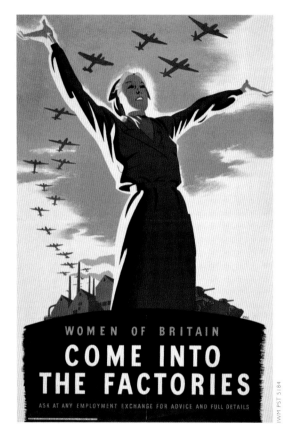

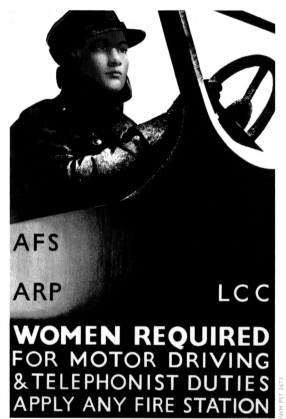

The similarity of Zec's poster to images of heroic workers in Soviet propaganda has often been remarked upon. Some historians claim it reflects the Anglo-Soviet alliance existing at the time, or the mood of egalitarianism pervading the British home front.[4] Philip Zec, a cartoonist for the *Daily Mirror*, was renowned for his socialist views and his sometimes controversial cartoons.

4. See David Crowley, 'Protest and Propaganda' in Timmers. Margaret (Ed): *The Power of the Poster*, V&A Publications (London), 1998, p.124

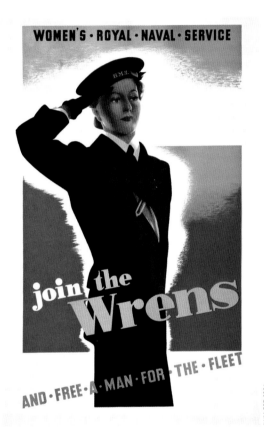

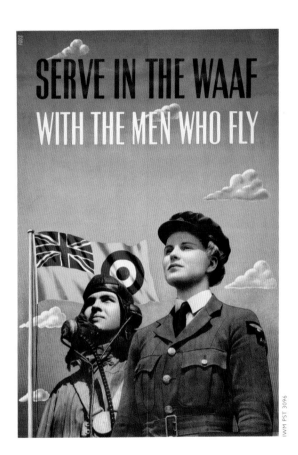

In this recruiting poster for the Women's Auxiliary Air
Force, Foss presented an image of female confidence and
parity with male colleagues. Foss conceived the design from
an earlier poster, *Volunteer for Flying Duties*, adding
a photograph of WAAF member Mary Scaife.

HANS **SCHLEGER (ZÉRÓ)**

1898–1976

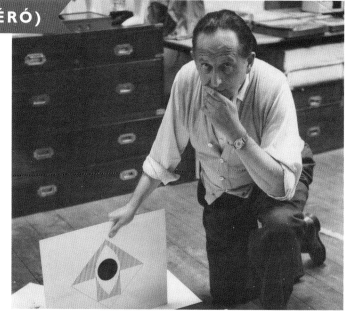

Hans Schleger in his studio
with the Design Centre symbol.
The symbol was designed
for the opening of the
Centre in 1955.

Hans Schleger was born into a middle-class Jewish family in Kempen in eastern Germany. As a child he was sometimes rebellious, preferring to draw in school lessons rather than study. Yet through his love of drawing, Schleger developed an interest in graphic art and after serving in the First World War he enrolled at the National School of Applied Art in Berlin in 1919. While a student there he was influenced by the Bauhaus design movement, and also developed an interest in emerging human mind sciences such as Freudian psychoanalysis. Both would have a lasting impact on his work.

On leaving art school Schleger worked initially as a designer for the film company Hagenbeck, but in 1924 he decided to move to New York. There Schleger adopted the pseudonym *Zéró* and gained prominence through his humorous drawings and advertisements for magazines like the *New Yorker*. His growing reputation as a Modernist *émigré* designer eventually allowed Schleger to work freelance, and in 1926 he set up studio on Madison Avenue.

Schleger's success in America was abruptly halted by the Wall Street Crash in 1929 and he returned to Germany to become art director in the Berlin office of the British advertisers W S Crawford Ltd. Anticipating the rise of the Nazis, Schleger moved permanently to Britain in 1932. His arrival coincided with an exciting period of poster design and enlightened publicity and he quickly received commissions to design posters and advertisements for Shell-Mex and London Transport. Schleger's posters were particularly notable for their surrealist tendencies, reflecting the avant-garde movement's prevalence in Europe as well as his own interest in theories of the subconscious.

The outbreak of the Second World War caused particular distress to Schleger and wartime conditions meant that commercial work was also difficult to come by. However, Britain's war effort gave him purpose and he contributed typically humorous and surreal poster designs to the General Post Office, London Transport and the Ministry of Food. After the war, Schleger pioneered the new concept of 'corporate identity' with his marketing and merchandising campaign for the Mac Fisheries food shop chain between 1952 and 1959. He also created many company symbols and trademarks for clients such as Penguin Books and the John Lewis Partnership.

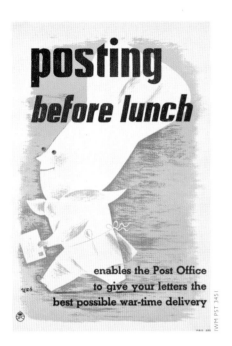

posting
before lunch

enables the Post Office
to give your letters the
best possible war-time delivery

IWM PST 3451

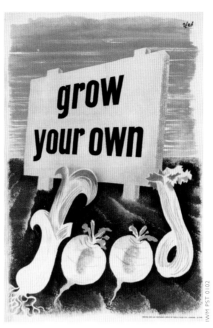

grow
your own
food

IWM PST 0102

ALL **HANS SCHLEGER**
(ZÉRÓ) 1898–1976

POSTING BEFORE LUNCH
(C.1942)

GROW YOUR OWN
FOOD (1942)

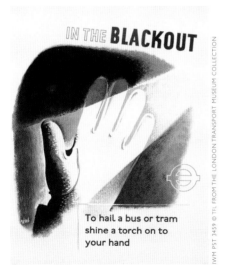

IN THE BLACKOUT

To hail a bus or tram
shine a torch on to
your hand

IWM PST 3459 © TfL FROM THE LONDON TRANSPORT MUSEUM COLLECTION

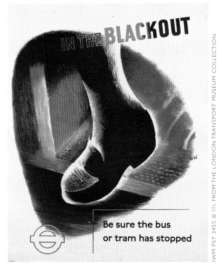

IN THE BLACKOUT

Be sure the bus
or tram has stopped

IWM PST 3455 © TfL FROM THE LONDON TRANSPORT MUSEUM COLLECTION

IN THE BLACKOUT –
TO HAIL A BUS OR TRAM...

IN THE BLACKOUT –
BE SURE THE BUS OR
TRAM... (BOTH 1943)

PAT KEELY (C.1900s–1970)
WEAR YOUR GOGGLES
(1942)

3. SAFETY FIRST

POSTERS OF THE ROYAL SOCIETY
FOR THE PREVENTION OF ACCIDENTS

Between 1940 and 1945 The Royal Society for the Prevention of Accidents (RoSPA) produced over two hundred different poster designs promoting a range of industrial safety measures. Remarkable for their prevalent use of Modernist aesthetics – to the extent that they were displayed at New York's Museum of Modern Art in 1944 – these posters exemplified Britain's approach to visual propaganda during the Second World War.

The origins of RoSPA lay in the First World War. In 1916 a London 'Safety First' Council was elected in response to rising traffic accidents, many of which were believed to be caused by blackout conditions. This council formally became the National Safety First Association in 1923. At the outbreak of the Second World War, the association's main concern was once again accident prevention under renewed blackout conditions. Campaigns successfully cut road deaths by almost a quarter.

In 1941 the charity renamed itself The Royal Society for the Prevention of Accidents after the Ministry of Labour and National Service, under Ernest Bevin, invited it to produce a series of posters promoting industrial safety. The recruitment of a large but inexperienced industrial workforce, coupled with the need to maintain optimum levels of war production, meant that workplace safety was of paramount importance to the war effort. Bevin, a friend of Frank Pick of London Transport [5] (see page 29),

was aware of the potential of poster publicity to promote safety in the workplace.

In organising these safety campaigns, RoSPA enlisted the highly-respected designer and advertising executive Ashley Havinden (1903–1973) as creative director. With his knowledge of European and Russian graphic styles, Havinden assembled an outstanding team. *Émigré* talents such as the German-born H A Rothholz (1919–2001) worked alongside young British designers experimenting with avant-garde styles, including Tom Eckersley (1914–1997), Pat Keely (c.1900s–1970) and G R Morris (*active* 1937–1956). Havinden's team sought to improve industrial safety not through posters bearing forceful slogans and imagery, but rather tried to engage a large, mixed workforce through arresting graphics derived from Continental art forms such as Surrealism, Cubism and photomontage. This they hoped would build unity and collective responsibility on the shop floor.

In total, 550,000 copies of the RoSPA posters were supplied nationwide. Wartime economies meant that the printing firm, Loxley Brothers of Sheffield, often printed designs on both sides of the paper and left it to factory safety representatives to decide which side to display. Nevertheless, RoSPA's stipulations for designated areas in which to show the posters would have ensured an extraordinary show of modern art for employees.

5. Paul Rennie makes original reference to Pick and Bevin's friendship in the article 'Social Vision' published by *Eye Magazine* No 52, Summer 2004

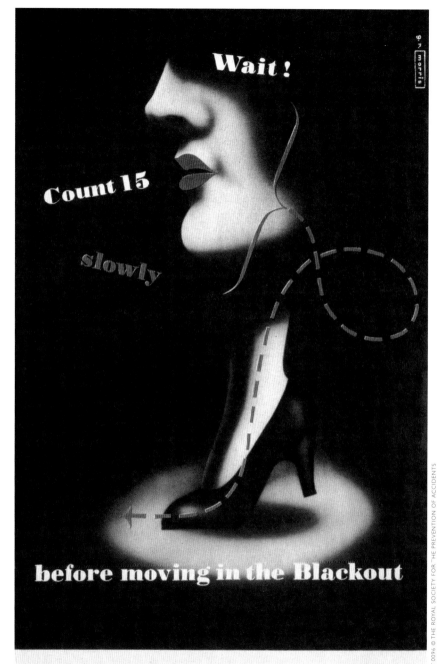

IWM PST 4770 © THE ROYAL SOCIETY FOR THE PREVENTION OF ACCIDENTS

ARTHUR GEORGE
MILLS (1907–?)
GO WARILY AFTER DARK
AND GET THERE (1940)

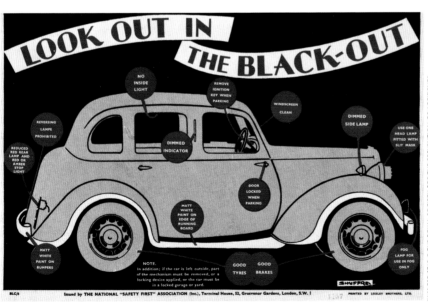

IWM PST 0719 © THE ROYAL SOCIETY FOR THE PREVENTION OF ACCIDENTS

REGINALD ALLEN
SHUFFREY (1886–1952)
LOOK OUT IN THE
BLACK-OUT (1939)

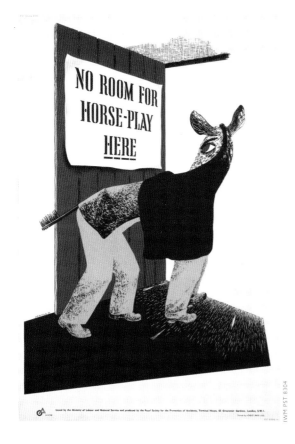

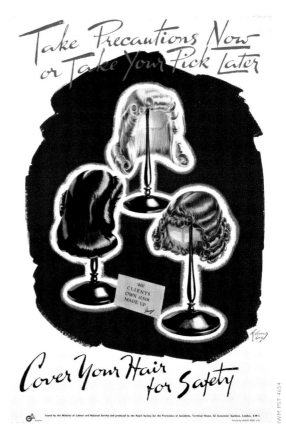

The German-born designer Rothholz found a novel means
of stressing the dangers of tomfoolery in the workplace
(above left). Despite having been resident in Britain since
1933, Rothholz was interned as an enemy alien in 1940 and
transported to Canada. He was eventually released in 1942,
and on return to Britain produced poster designs for the
General Post Office as well as RoSPA.

Eckersley was one of RoSPA's most prolific designers, creating
over twenty separate posters for the charity. As with other
RoSPA posters, Eckersley's designs derived their power
from the novelty and clarity of Modernist graphics.

TOM **ECKERSLEY**

1914–1997

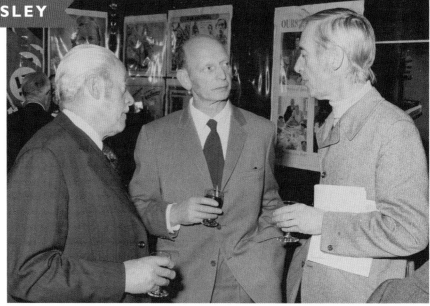

Tom Eckersley (right) in conversation with Abram Games and Reginald Mount at the Imperial War Museum in 1972

Tom Eckersley was born in Lowton in Lancashire, the son of a Methodist minister. As a child Eckersley suffered ill-health and spent much time drawing alone. His artistic abilities were noticed by his mother who encouraged him to enrol at the Salford School of Art in 1930, aged 15. While at Salford he became interested in avant-garde graphic art, in particular the posters of the French graphic artist AM Cassandre (1901–1968) and the American-born Edward McKnight Kauffer (1890–1954). His interest was shared by a fellow student, Eric Lombers (1914–1978) and together they set up a design studio in London in 1934 to produce posters and publicity for London Transport, Shell-Mex and the General Post Office (GPO).

The Second World War brought the partnership to an end, with Lombers conscripted into the Army and Eckersley into the Royal Air Force (RAF). While serving in the RAF, Eckersley managed to combine duties as a technical draughtsman and cartographer with poster design for the Royal Society for the Prevention of Accidents (RoSPA). This often meant hurriedly producing posters in 24-hour spells of home leave, working by lamplight and using a Morrison shelter as a work space.[6] The resulting posters were characterised by an almost abstract simplicity and a uniformity of design, which gave clarity and coherence to the important safety messages. Eckersley's later transfer to the Air Ministry enabled him to live at home, and under easier

circumstances he eventually created 22 posters for RoSPA plus numerous designs for the GPO and London Transport.

After the war Eckersley worked freelance, continuing to create posters despite their declining use as a marketing tool. During the 1970s and 1980s he simplified his designs further, using coloured paper to produce striking posters for the London Underground, the World Wildlife Fund and the Imperial War Museum. Appointed an OBE in 1948, Eckersley held the post of Head of Design at the London College of Printing from 1958 to 1976.

6. From 'Introduction' by George Him in *Tom Eckersley: Posters and other graphic work* exhibition catalogue, Arkwright Arts Trust, 1980, p.6

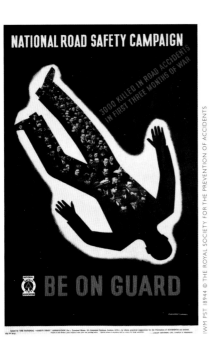

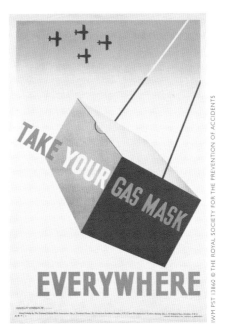

ECKERSLEY-LOMBERS
NATIONAL ROAD SAFETY
CAMPAIGN – BE ON
GUARD / TAKE YOUR
GAS MASK EVERYWHERE
(BOTH 1939)

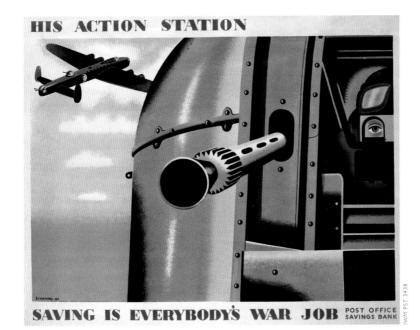

TOM ECKERSLEY (1914–1997)
HIS ACTION STATION –
SAVING IS EVERYBODY'S
WAR JOB (1943)

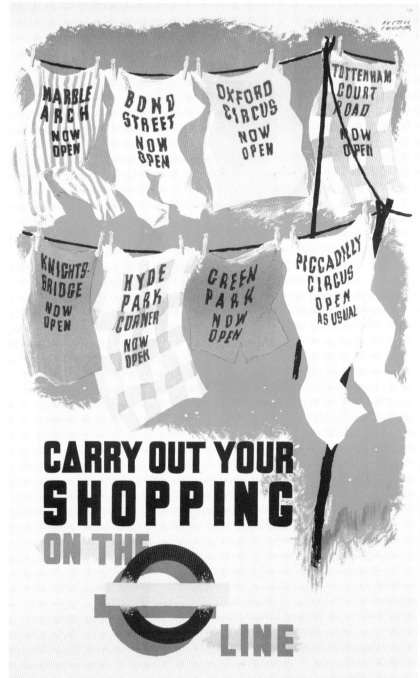

4. THEY ALSO SERVE

THE WARTIME POSTERS OF THE LONDON UNDERGROUND

By the outbreak of the Second World War the London Passenger Transport Board was already renowned for its poster art, which provided the central facet of a carefully-crafted corporate identity. This identity extended as far as the station architecture, the font adorning Underground signage, and even the design of the seating upholstery. It was largely the vision of one man: Frank Pick (1878–1941).

Pick, who became Managing Director of the newly created London Passenger Transport Board in 1933, had a passion for good design and a flair for publicity. From the start of his career at London Underground, where he began first as a personal assistant in 1906 and later became a publicity officer, Pick understood the poster's potential to raise awareness of under-used Underground services. However, frustrated with the limited designs of London print houses, he invited artists and illustrators to try their hand. This quickly established the Underground a reputation as an art patron, offering opportunities to young designers experimenting with Continental avant-garde styles. Pick, in turn, took pride in the belief that his posters had influenced taste by bringing modern art to the masses.

During the Second World War, aside from providing important information about disruption to services, the Underground poster would also be utilised purely as propaganda.

In the First World War, Pick had refused to display mediocre official recruitment posters lest they compromise the Underground's high design standards. Instead he commissioned his own recruiting posters. Likewise, during the Second World War – and despite the resignation of Pick in 1940 – the Underground felt impelled to institute its own propaganda campaigns to run adjacent to those of the government.

Seeing It Through, a series of five posters produced in 1944, was typical of the Underground's approach. Principally intended to boost morale, but with more than a hint of self-reverence, this series championed the heroism of ordinary transport workers. Although much in keeping with the spirit of a 'people's war', the academic style of Eric Kennington's portraits and the inclusion of verse by the dramatist and politician AP Herbert invested the posters with a high-minded romanticism which was uncharacteristic of official British propaganda.

The same lyricism imbued the 1944 series *The Proud City* by Walter Spradbery (page 33), which focussed on key London landmarks amid war ruins. Although Spradbery feared the commission would result in the bleakest posters ever, they were intended as a reminder of the indomitable spirit of London, rising from the Blitz to continue the fight against tyranny. In all, 27,000 copies of this series were produced, and some were exported overseas.

BRUCE ANGRAVE
(1914–1983)
WHEN ALIGHTING WAIT
UNTIL THE BUS IS REALLY
STANDING STILL / PAUSE
AS YOU LEAVE THE
STATION'S LIGHT / MAKE
SURE IT IS THE PLATFORM
SIDE / IN THE BLACKOUT
A FLASHING TORCH IS
DANGEROUS (1942)

The imposition of
blackout conditions
in London meant that
otherwise mundane
activities – such as
flagging down buses
or leaving brightly
lit Underground
stations – were
potentially hazardous.
In response to a rising
toll of transport-
related accidents,
London Transport
produced a series of
posters between 1940
and 1943 to warn
of potential risks
and to encourage
travellers to adjust
their behaviour
accordingly. In
these four posters
the illustrator Bruce
Angrave took a
typically light-hearted
approach to alerting
commuters of
blackout dangers.

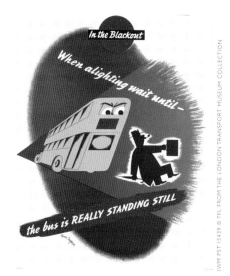

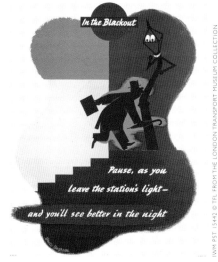

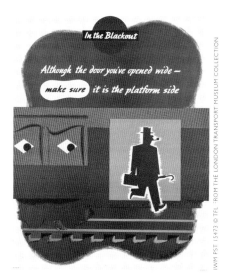

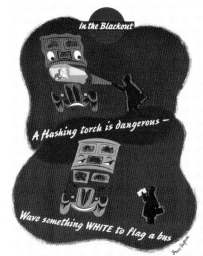

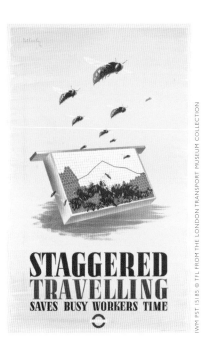

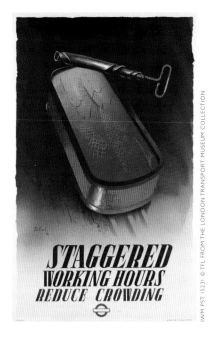

PAT KEELY (C.1900s–1970) STAGGERED TRAVELLING SAVES BUSY WORKERS TIME (1945) / STAGGERED WORKING HOURS REDUCE CROWDING (1945)

Keely's imaginative posters elicited assistance from travellers in order to maintain a transport service which was being operated by a depleted workforce. Fougasse's humorous calls for considerate passenger behaviour (below) remain pertinent today.

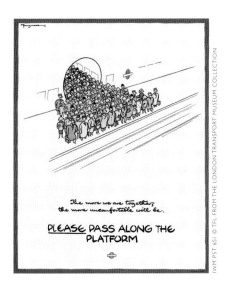

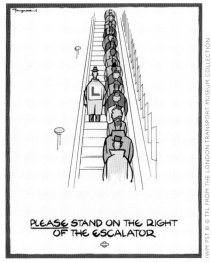

'FOUGASSE' (CYRIL KENNETH BIRD, 1887–1965) PLEASE PASS ALONG THE PLATFORM (1944) / PLEASE STAND ON THE RIGHT OF THE ESCALATOR (1944)

London Transport
began commissioning
posters which visualised
the end of the war
as early as January
1944. Anna Zinkeisen's
somewhat sentimental
poster was meant as
a gesture of thanks to
London Transport staff
and patrons for their
contribution to the war
effort. Circulated after
the Allied invasion of
Europe, it combined the
promise of imminent
peace with the prophetic
words of Winston
Churchill in 1940.

"The day will come when the joybells will ring again throughout Europe,
and when victorious nations, masters not only of their foes but of themselves,
will plan and build in justice, in tradition, and in freedom . . ."

The Rt. Hon. WINSTON S. CHURCHILL, C.H., M.P. Jan. 20th, 1940

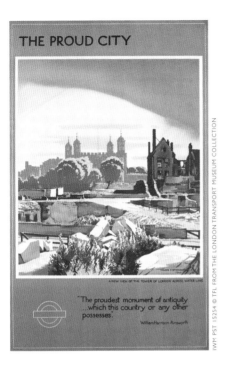

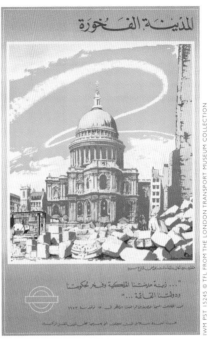

WALTER SPRADBERY (1889–1969) THE PROUD CITY – A NEW VIEW OF THE TOWER OF LONDON ACROSS WATER LANE (1944) / THE PROUD CITY – A NEW VIEW OF SAINT PAUL'S CATHEDRAL FROM BREAD STREET (1944)

The domestic popularity of Spradbery's Proud City series prompted its export overseas, with versions of the posters translated into Portuguese, Arabic and Persian.

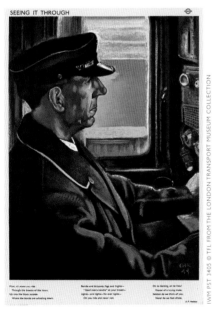

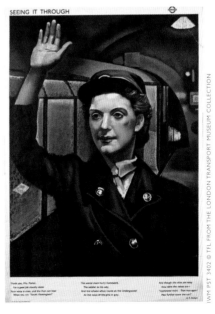

ERIC HENRI KENNINGTON (1888–1960) SEEING IT THROUGH – PILOT, ALL ALONE YOU RIDE (1944) / SEEING IT THROUGH – THANK YOU, MRS PORTER (1944)

Created by the
Ministry of
Information for
the Ministry of
Agriculture and
Fisheries, this
poster not only
became the
signature of the
'Dig for Victory'
campaign for
the remainder of
the war, but also
came to embody
the whole British
propaganda effort
of the Second
World War. The
importance of
self-sufficiency
was emphasised –
with a note of
wry humour – in
bestowing epic
grandeur to the
mundane task of
kitchen gardening.

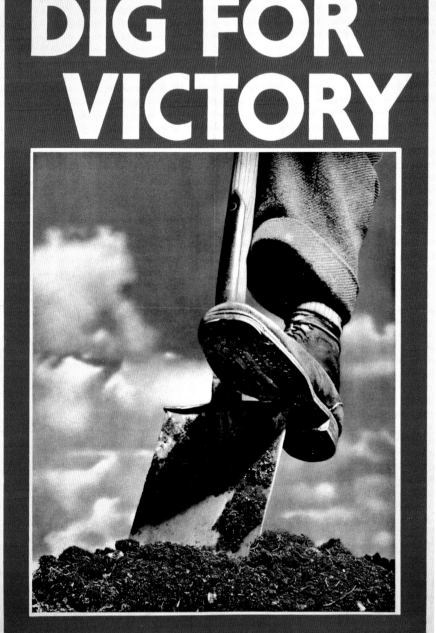

5. THE KITCHEN FRONT

FOOD RATIONING AND PRODUCTION IN WARTIME BRITAIN

In 1939, Britain was no better placed to feed itself than it had been during the German U-boat campaign of the First World War. Reliance on cheap imports from the Empire meant only 30 per cent of food resources were home-produced. Rationing was therefore inevitable and plans were already in place at the outbreak of war for a Ministry of Food (MOF) to take immediate control of the supply and distribution of limited food stocks.

In April 1940 Chamberlain made Lord Woolton Minister of Food. Knowing the success of rationing rested upon the goodwill of the public, Woolton expertly oversaw a publicity drive involving the popular comedy duo 'Gert and Daisy' and advice from the BBC's 'Radio Doctor', Charles Hill.

In addition to rationing, ingenious ways were devised to make the best of alternative or substitute foodstuffs (those items not 'on the ration') to maintain the nation's nutritional health. These methods were largely the conception of the pioneering nutritionist Jack Drummond. Both Drummond and Woolton shared an interest in social affairs, and saw in rationing not simply a means to reduce the effects of naval blockade, but an opportunity to improve the nation's health as a whole. To this end the MOF turned to the popular cartoonist, James Fitton (1899–1982) to devise posters promoting good nutritional habits.

Fitton, who prior to the war had contributed cartoons to the Communist *Daily Worker* and the *Left Review*, shared the MOF's reforming zeal and delivered four posters encouraging a wider consumption of vegetables and more milk for children (page 38–39).

Sister department to the MOF was the Ministry of Agriculture and Fisheries, charged with implementing the second strand of Britain's response to Germany's blockade: self-sufficiency. To do so it initiated the 'Dig for Victory' campaign, which encouraged people to turn gardens, municipal parks, and even roadside verges into vegetable plots. Instituted in 1939, publicity for the scheme was initially low-key, often taking the form of simple notices. However, from 1941 a widening publicity campaign overseen by the Ministry of Information spawned the most famous poster of the war (opposite). Published in 1941, the iconic boot and spade image accompanied a promotional film bearing the same motif. Featuring the boot of retired music hall performer and keen allotment gardener William Henry McKie, the poster perfectly summarised the scheme's objectives.[7] It quickly became emblematic of 'Dig for Victory' and was used repeatedly in several poster formats for the rest of the war.

7. Information supplied by Steve Thomas, great-grandson of William Henry McKie, on 4 February 2010

JAMES GILROY (1898–1985)
WE WANT YOUR KITCHEN
WASTE (1941)

Pigs were invaluable
to the British wartime
food economy as
they could be fed on
food waste. Posters
such as this by
Gilroy, famous for his
pre-war Guinness
advertisements, urged
people to save kitchen
scraps for council
collection. Across
Britain, pig rearing
also assumed a more
localised dimension
with almost seven
thousand 'Pig Clubs'
formed to supplement
food rations.

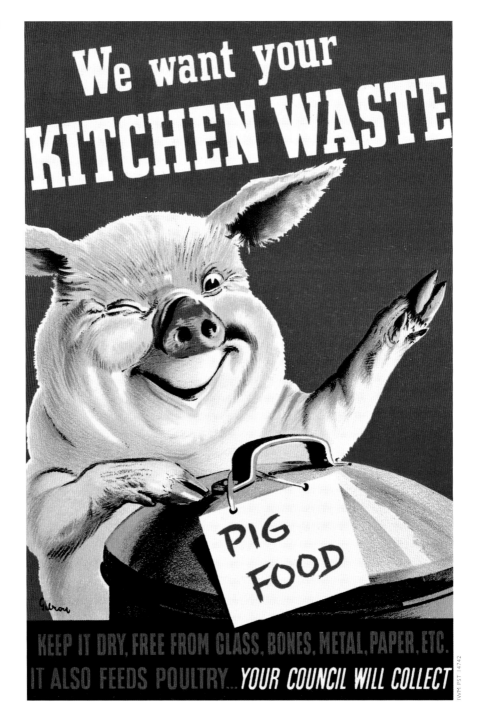

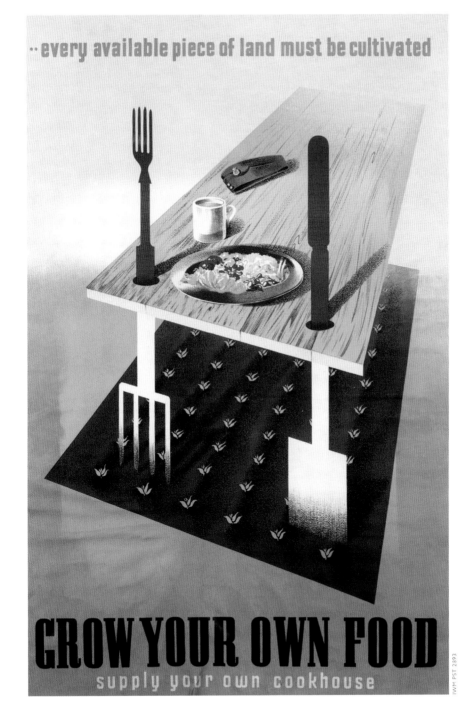

ABRAM GAMES (1914–1996)
GROW YOUR OWN FOOD
(1942)

JAMES FITTON
(1899–1982)
MILK – THE BACKBONE OF
YOUNG BRITAIN (C. 1942)

Increasing calcium
intake amongst
vulnerable sections
of British society
was a priority for
the Ministry of Food,
resulting in increased
milk rations for
pregnant women
and children. The
initiative's legacy
would be the provision
of free milk for all
schoolchildren from
1946, a scheme that
remained largely
intact until 1971.

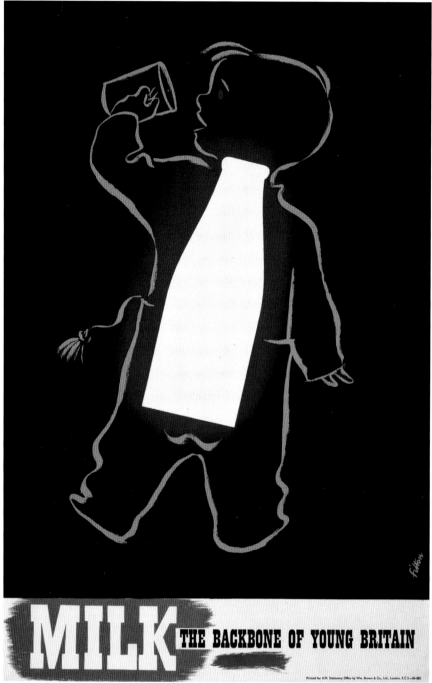

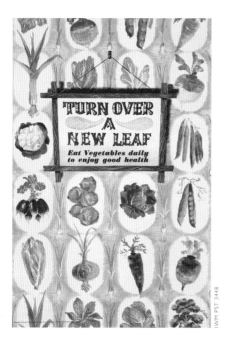

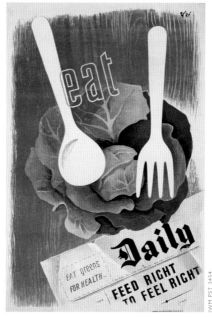

JAMES FITTON (1899–1982)
TURN OVER A NEW LEAF
(C.1942)

HANS SCHLEGER (ZÉRÓ)
(1898–1976)
EAT GREENS FOR HEALTH
(1944)

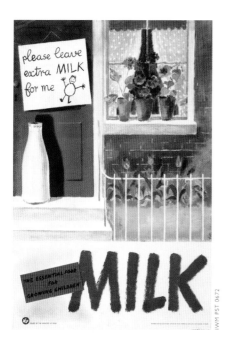

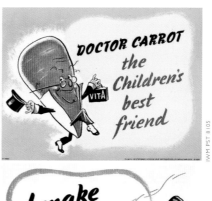

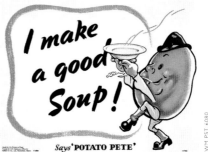

JAMES FITTON (1899–1982)
MILK – THE ESSENTIAL FOOD
FOR GROWING CHILDREN
(C.1942)

UNKNOWN
DOCTOR CARROT (1941)
I MAKE A GOOD SOUP
[POTATO PETE] (1941)

The MOF introduced the humorous characters Dr Carrot and Potato Pete to promote greater and varied use of non-rationed foods, especially among children. The health benefits of these foods were emphasised, even exaggerated. Notably, a surplus of carrots led to the suggestion that the vegetable improved night vision – particularly amongst pilots.

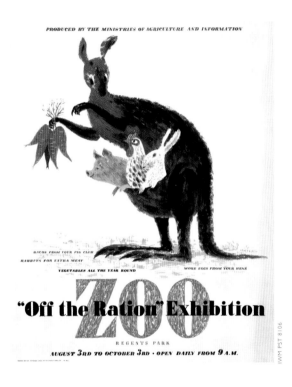

Lewitt-Him's light-hearted poster publicised the Ministry of
Information's *Off the Ration* exhibition held at London's Regent's
Park Zoo in 1941. The exhibition, designed by FHK Henrion,
proposed not the consumption of the Zoo's inhabitants, but
instead offered ways in which the public could supplement
rationed food by keeping rabbits, poultry or pigs.

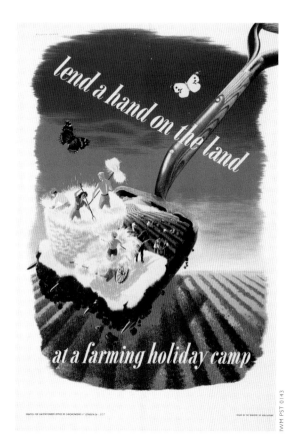

Shortages in agricultural labour prompted the 'Lend a Hand on the Land' initiative in 1943, which encouraged families to take inexpensive 'working holidays' assisting with summer harvests. The scheme sought in spirit to reflect established traditions such as the annual migration of Londoners for the Kent hop-pick.

ABRAM **GAMES**

1914–1996

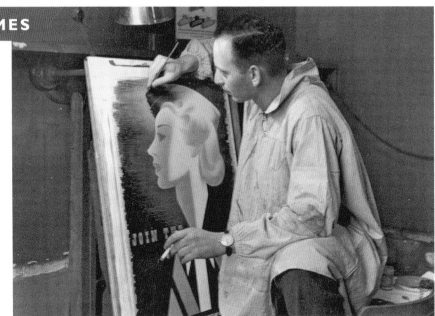

Abram Games in his War Office studio in July 1941, at work on the notorious 'Blonde Bombshell' poster design (see page 74–75)

Abram Games was one of the twentieth century's most important and influential designers.

Born Abraham Gamse in Whitechapel in London, the son of a Jewish-Latvian photographer, Games was largely self-taught. He briefly attended St Martin's School of Art in 1930 but left after two terms, dissatisfied with the teaching and worried about the expense of course fees.

Games's ambition was always to become a freelance 'poster artist' in the manner of continental masters he admired, such as Ludwig Hohlwein (1874–1949). However, his career began as a lowly studio technician in 1936 for the commercial artists Askew and Younge. Games grew quickly frustrated with the staid approaches of his employers and they, in turn, tiring of his 'independent views', eventually sacked him. This dismissal provided the impetus

for Games to become a freelance poster artist. This was a remarkably bold step given his youth and inexperience, yet Games's skill and single-mindedness eventually resulted in his designs being noted in the influential design journal *Art and Industry* in 1937. From there he secured poster commissions from prestigious patrons including the General Post Office.

At the beginning of the Second World War, Games was conscripted into the army, only to be summoned in 1941 by the Public Relations Department of the War Office. They were looking for someone to create a design for a recruitment poster for the Royal Armoured Corps, and Games had the good fortune of appearing first on their alphabetical list of enlisted designers. Made Official War Office Poster Artist, he was given almost a free hand and created some of the most outstanding and, at times,

controversial posters of the war. Applying his famous principle 'maximum meaning, minimum means', Games's posters, targeted mainly at British troops, derived their power from arresting visual puns and were often characterised by a dreamlike quality reminiscent of the surrealist paintings of Salvadore Dali (1904–1989).

Idealistic by nature, Games felt that the quality of his wartime posters stemmed from the morality of Britain's cause. They certainly established his reputation, enabling him to achieve fame post-war with symbols for the Festival of Britain in 1951 and the BBC in 1953. A lifelong supporter of humanitarian causes, Games also produced posters for a number of Jewish charities and most famously the *Freedom from Hunger* poster for the United Nations in 1960. He was appointed an OBE in 1958.

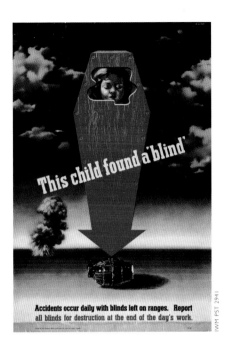

IWM PST 2941

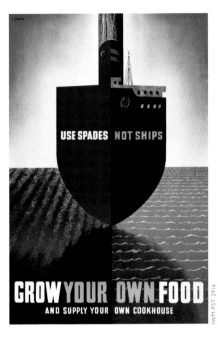

IWM PST 2916

ALL **ABRAM GAMES**
(1914–1996)

THIS CHILD FOUND
A 'BLIND' (1943)

USE SPADES NOT SHIPS –
GROW YOUR OWN FOOD
(1942)

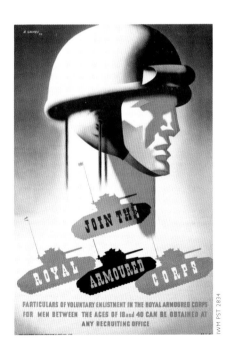

IWM PST 2834

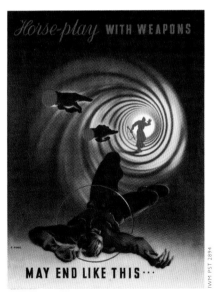

IWM PST 2894

JOIN THE ROYAL
ARMOURED CORPS
(1941)

HORSE-PLAY WITH
WEAPONS MAY END
LIKE THIS... (1942)

UNKNOWN
MAKE DO AND
MEND (C.1942)

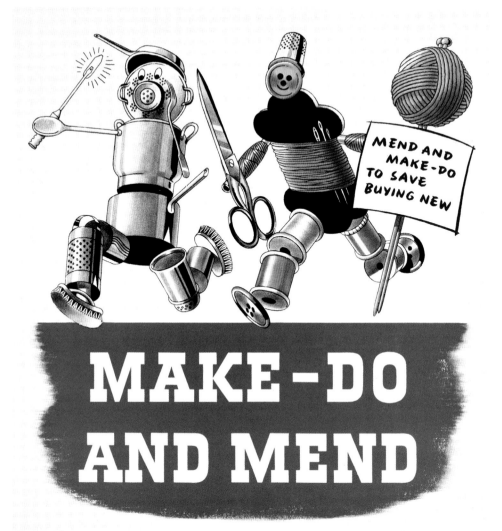

6. ADVERTISING AUSTERITY

POSTERS OF WARTIME ECONOMY

During the Second World War, Britain's dependency on foreign imports, together with the need for factories to switch to war production, resulted in a host of shortages. As war continued the rising consumerism of the 1930s ground to a halt, and Britain was condemned to a grim period of austerity lasting until the 1950s.

Shortages in paper supplies (caused by the German occupation of Norway in 1940) had a direct impact on British commercial artists and designers. Advertising, hit already by restrictions on the free market, virtually ceased as dwindling paper stocks were channelled to the war effort. Many designers therefore turned to work in propaganda, providing a rich pool of talent at government disposal. For the designers there was the kudos and respectability of government employment, plus the chance to add fresh dimensions to their work. As such many, despite returning to commercial work in 1945, continued to undertake government publicity long after the war.

Depleting textile resources saw President of the Board of Trade Oliver Lyttelton introduce clothing rationing in June 1941. Each person was issued with 66 clothing coupons, meaning that from now on the onus was on better care and recycling of existing clothes. To this end the Board of Trade initiated the 'Make Do and Mend' campaign in 1942, with the Ministry of Information (MOI) again on hand to organise

exhibitions, set up advice centres and distribute pamphlets. As with other potentially unpopular British wartime policies, MOI publicity for 'Make Do and Mend' centred on specially created characters to deliver the common touch. Adorning the posters outside advice centres was firstly a cheery figure made of cotton spools, thimbles and buttons (opposite) and then, more famously, Mrs Sew and Sew (see page 48).

Developed in 1943 by the advertising agency WS Crawford Ltd, Mrs Sew and Sew was an appropriation of the 'brand character', a long-standing feature of British commercial advertising. Just as characters like the gravy-loving Bisto Kids were successful forms of product branding, it was hoped that Mrs Sew and Sew would provide an easily identifiable campaign trademark to encourage thrifty needlecraft within British households.

The Squanderbug (page 49), created by the illustrator Phillip Boydell (1896–1984), was yet another trademark character accompanying a government propaganda initiative. Surreptitiously targeted at the female workforce – those 'unused to wages' – this campaign attempted to discourage 'wasteful' expenditure on consumer goods and supported instead investment in government National Savings schemes. Despite its anti-consumerist promotion of austere measures, the Squanderbug proved highly popular with the British public.

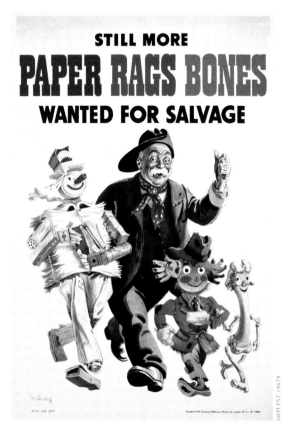

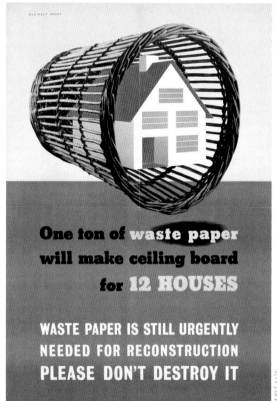

Gilroy worked for the Ministry of Information during the war, following success as an in-house artist for the advertisers S H Benson Ltd in the 1920s and 30s. In support of the Ministry of Supply's salvage drive he created a jovial rag and bone man as a campaign trademark. Featuring in four separate posters by Gilroy and used by other designers, the character was in many ways derived from the famous zookeeper image which appeared in Gilroy's 1930s Guinness advertisements.

The end of the war by no means brought an end to shortages and the need to recycle. Britain faced an acute lack of housing thanks to German bombing raids, but supplies of building materials were scarce. Mount's poster outlined plainly the need to continue salvaging paper.

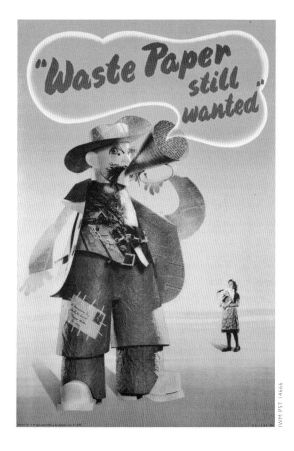

IWM PST 14666

IWM PST 14680

Mount and Evans provided a novel variation on John Gilroy's cheerful rag and bone man (see opposite) in this later poster. Evans had originally worked as a filing clerk in the MOI's photographic division but was quickly moved to its design studios once her artistic ability was noticed. There she formed a professional partnership with Mount which continued after the war, producing public information posters for the MOI's successor, the Central Office of Information, during the 1950s and 60s.

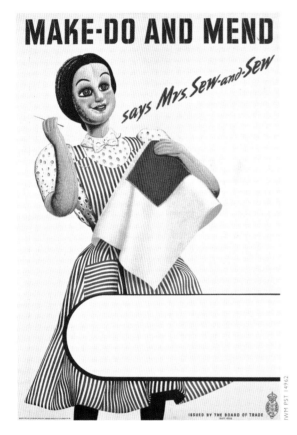

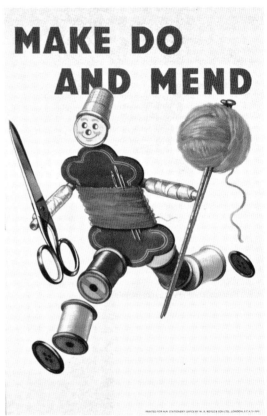

Intended to publicise 'Make Do and Mend' advice centres,
these two posters were deliberately printed with blank areas
to enable the details of local centres to be written in.

PHILLIP BOYDELL
(1896–1984)
WANTED FOR
SABOTAGE (THE
SQUANDERBUG)
(1943)

The Squanderbug first appeared in press adverts, but quickly developed a life of its own after use in several poster designs. A highly successful example of campaign branding, it made appearances in the cartoons of David Low and Carl Giles. It was even exported abroad, with the famous American children's illustrator, Dr Seuss, creating an equivalent creature to promote United States War Bonds.

IWM PST 3406

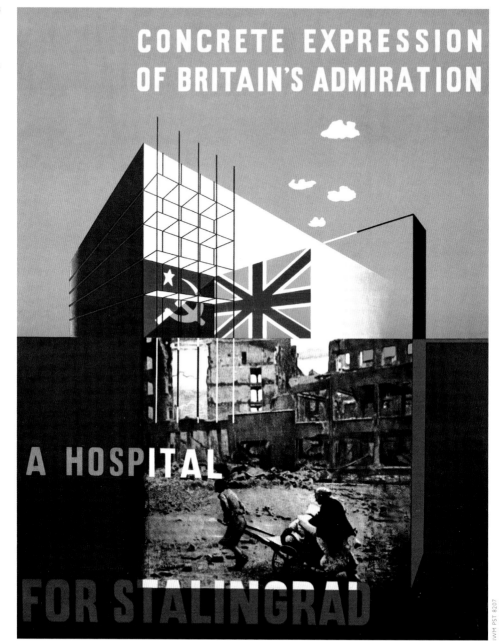

IWM PST 8207

7. STRANGE BED FELLOWS

PROPAGANDA OF THE ANGLO-SOVIET ALLIANCE

Although Germany's invasion of the Soviet Union in June 1941 provided Britain with a much-needed ally, it also presented the Ministry of Information (MOI) propagandists with a serious two-fold dilemma. Firstly, how was an alliance with a totalitarian regime to be presented to a nation engaged in a war *against* another such regime? And secondly, how could this alliance be promoted without enamouring Communism to the British public?

At the beginning of the war the Molotov-Ribbentrop Pact and the division of a defeated Poland between Germany and the Soviet Union had seemed the logical outcome of Soviet dictator Joseph Stalin's unscrupulous opportunism. It provided rich material for early British propaganda in regions such as the Middle East where both regimes sought influence (see page 52).

But whilst Stalin's enforced change of allegiance in 1941 posed problems for some, others in Britain viewed the new alliance more pragmatically. The Minister of Supply, newspaper magnate Lord Beaverbrook, headed a delegation to Moscow in October 1941 to consolidate Anglo-Soviet co-operation. As a gesture of goodwill Beaverbrook's hosts presented him with a collection of propaganda posters. This gift formed the basis of the MOI's *Comrades in Arms: Pictures of the Soviets at War* exhibition in 1942 (see page 54). Introducing to the British public the strident propaganda of the Soviet Union,

Beaverbrook had English translations created for display in British war factories.

Comrades in Arms introduced the MOI's approach to promoting the Anglo-Soviet alliance. The Ministry decided that henceforward the Russian Front would be interpreted for the British public as a patriotic struggle, waged by an heroic and self-sacrificing people defending their homeland. Thus any potentially seductive references to Soviet doctrine or leadership were discretely avoided.

This stance on Russia also aimed to undermine the Communist Party in Britain. Prior to June 1941 the Party had campaigned against British involvement in the war, but Germany's invasion of the Soviet Union immediately reversed this position and the Party faithful rallied to the national cause. This caused alarm in government and, fearing that the Communists were capitalising on growing public interest in the Soviet Union, the MOI instituted a policy of non-cooperation with the Party.

Denied MOI posters and leaflets to distribute, British Communists produced their own propaganda. Relying heavily upon Soviet-inspired cartoon polemics and dynamic photomontage, their posters' chief concern was the opening of a 'Second Front' in Western Europe.

'KEM' (KIMON EVAN
MARENGO 1907–1988)
THE PROGRESS OF SOVIET-
GERMAN CO-OPERATION
(1940)

British overseas
propaganda sought to
undermine the brief
alliance of Soviet and
Nazi dictatorships.
Note the similarity
between this poster,
by the Egyptian-born
cartoonist Kem, and
Beaverbrook's translated
Soviet propaganda
(opposite). Although
deemed unacceptable
for the British public,
such spiteful imagery
was obviously judged
suitable for foreign
consumption.

UNKNOWN
THE SO-CALLED
'HIGHER RACE' (1941)

UNKNOWN
RUSH BRITISH ARMS TO
RUSSIAN HANDS (1941)

F KENWOOD GILES
(ACTIVE 1925–1945)
COVER YOUR HAIR FOR
SAFETY (C.1941)

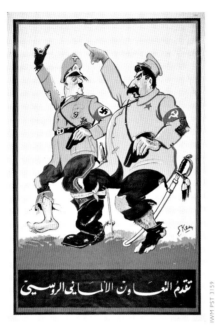

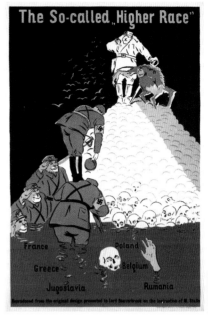

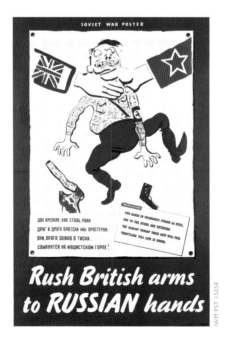

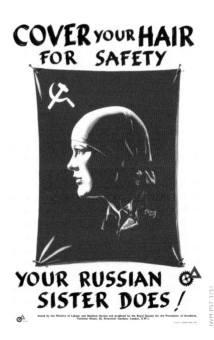

MANEATER

France
Greece
Jugoslavia
Rumania
Poland
Belgium

Reproduced from the original design presented to Lord Beaverbrook on the instruction of M. Stalin

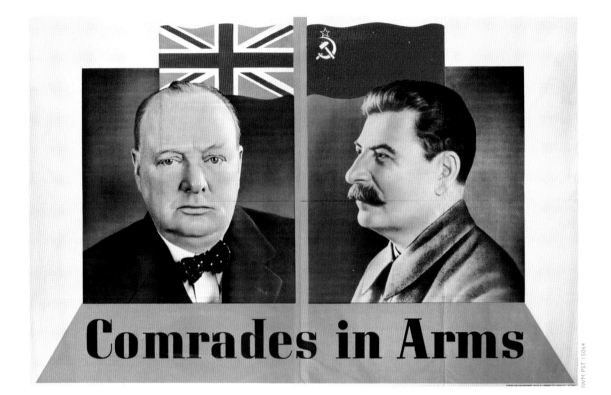

Even in this promotional poster for the MOI's pro-Russian exhibition at Charing Cross Underground station, Churchill, the avowed anti-communist, appears unable to hide his discomfort at his close proximity to the Soviet dictator.

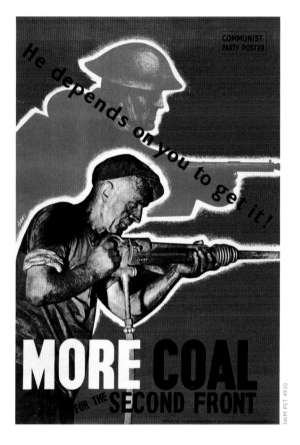

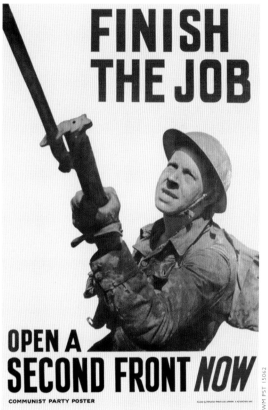

Many posters produced by the Communist Party of
Great Britain were characterised by their striking use of
photomontage, reminiscent of the Soviet Constructivists
of the 1920s. Davy's poster stressed the link between
home production and battlefield success by the mirrored
stances of the drilling miner and the advancing soldier.
Interestingly, this was a motif often to be found in
American production drive posters from both the
First and Second World Wars.

1914–1990

Henrion in the meeting area of his private studio. During this period he was organising visual aspects of the British pavilion at the Expo in Montreal in 1967.

© ESTATE OF FHK HENRION

Frederic Henri Kay Henrion was born in Nuremberg in Germany to Jewish-German parents. His father, a lawyer, wanted his son to follow him into the legal profession but Henrion, wishing instead to become a textile designer, ran away to Paris in 1933. In Paris, Henrion decided to become a graphic artist following work as an assistant to the French commercial artist, Paul Colin (1892–1985) in 1934. A short spell creating posters for the international Levant trade fair in Tel Aviv in 1936 was followed by a permanent move to Britain in 1939.

At the beginning of the war Henrion was briefly interned owing to his German background, but on release he joined the exhibitions division of the Ministry of Information.

He also created propaganda posters for the US Office of Information in London and the Dutch government in exile. Citing the German Dadaist artist John Heartfield (1891–1985) as a major influence, Henrion was a highly-skilled exponent of photomontage. This he incorporated into surrealist-inspired poster designs of austere elegance and simplicity.

Although Henrion's posters significantly influenced British graphic design, after the war he realised the medium was no longer at the forefront of publicity. By winning a design competition for a logo for the National Blood Transfusion Service in 1947, Henrion signalled a change of direction and he increasingly focused on 'corporate identity'. He later created logos for Girobank, the Dutch airline

KLM and the food manufacturer Tate and Lyle. Working freelance, Henrion continued to produce posters for causes he personally supported, most notably Oxfam and the Campaign for Nuclear Disarmament. He was also a respected teacher, lecturing at St Martin's School of Art and the Royal College of Art before becoming Head of Graphic Design at the London College of Printing from 1976–79. Henrion became a naturalised British citizen in 1946 and was appointed an MBE in 1951, and an OBE in 1985.

BOTH **FHK HENRION**
(1914–1990)

UNTITLED (1944)

ONE AIM – ONE WILL!
(1945)

IWM PST 4006

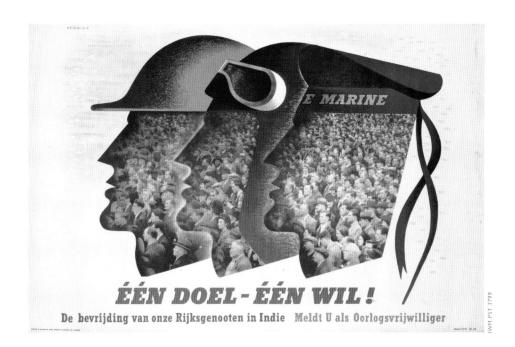

IWM PST 3799

ÉÉN DOEL - ÉÉN WIL !

De bevrijding van onze Rijksgenooten in Indie Meldt U als Oorlogsvrijwilliger

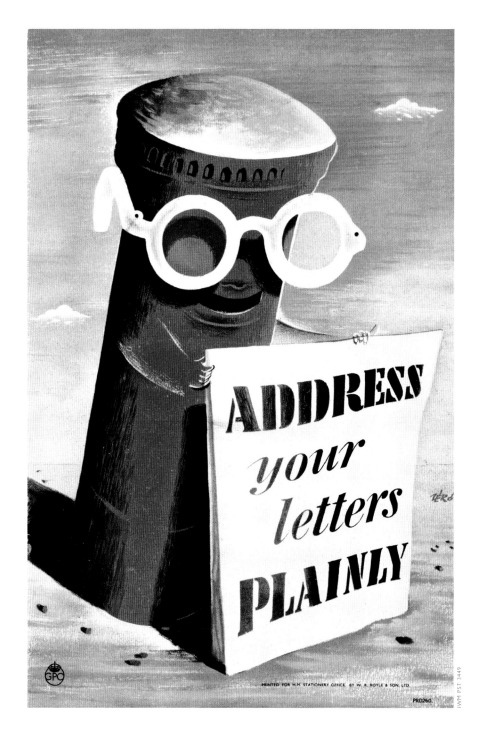

8. THINK AHEAD

THE POSTERS OF THE GENERAL POST OFFICE

In 1933 Sir Stephen Tallents (1884–1958) left the British government's Empire Marketing Board to become Public Relations Officer for the General Post Office (GPO). In just two years he had established a publicity programme to rival that of Frank Pick's at London Transport (see page 29). Like Pick, Tallents favoured a more aesthetically-minded approach to publicity. He formed a film unit, which produced the famous documentary *Night Mail* (1936), and employed the poets John Betjeman and WH Auden. Much like his contemporary at London Transport, Tallents acted as an art patron, commissioning artists and designers to produce innovative posters to advertise services and initiatives.

Much of Tallents's pre-war GPO publicity was aimed at enlisting the public's help to improve the efficiency of the postal service. This was done through posters encouraging people to post early to avoid delays in deliveries. During the Second World War the GPO's reliance on public support was greater than ever. In 1939 it was the country's largest employer, but conscription reduced the workforce by almost half. At the same time, the GPO's responsibilities increased as it was called upon to provide telecommunications for the armed forces and to distribute public information material. Poster campaigns persuaded people to write more letters to relieve pressure on stretched telephone and telegraph services. Other posters discouraged

postage during busy Christmas periods, and a drive to encourage people to 'address letters clearly' reflected the influx of inexperienced staff to replace those lost to the services.

Each of these campaigns drew upon the wealth of design talent assembled by Tallents in the 1930s. This included the Polish-born *émigré* partnership 'Lewitt-Him' (Jan Le Witt, 1907–1991 and George Him, 1900–1982), who were later joined by the German-born designer Hans Schleger ('Zéró', 1898–1976). Their use of Surrealism and unlikely pictorial juxtapositions proved highly effective.

Key to the GPO's pre-war publicity effort had been the so-called 'prestige poster', distributed in schools from late 1933 to teach the history of communication. These posters provided effective GPO propaganda, showing off its breadth and use of modern technology to deliver communications to the far flung corners of Britain and the Empire. In wartime the tradition of prestige posters continued with GPO propaganda boasting of its importance to the war effort. For example Pat Keely's (c.1900s–1970) *Wireless War* (overleaf), an indirect reference to the GPO's telephone Research Station at Dollis Hill, highlighted the Post Office's role in developing telecommunications for the armed forces.

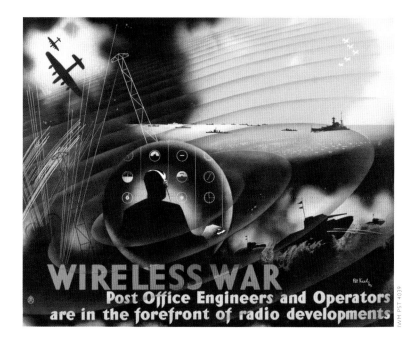

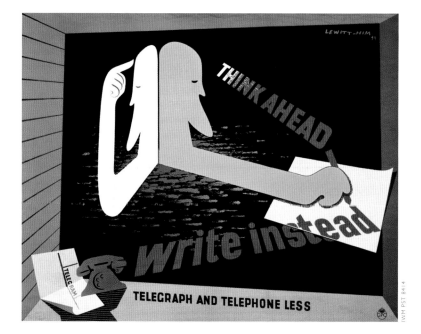

IN TOWN and COUNTRY

POST OFFICE

POST OFFICE
SAVINGS BANK

POST OFFICE
SAVINGS
BANK

BEAUMONT

P.B.59

there are 18,000 Branches
of the POST OFFICE
SAVINGS BANK

LEONARD BEAUMONT
(1891–1986)
IN TOWN AND
COUNTRY (C.1945)

The Post Office
Savings Bank
enabled people of
low to moderate
income to save
with the guarantee
of government. In
Beaumont's poster,
produced shortly
before the end of
the war, a scene
of English village
life suggested the
imminent return
of peacetime
stability, as well
as emphasising
the ubiquity of the
postal service.

IWM PST 18593

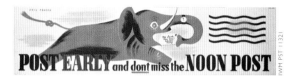

POST EARLY and don't miss the NOON POST

IWM PST 11321

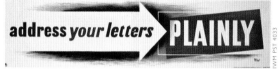

address your letters PLAINLY

IWM PST 4033

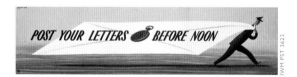

POST YOUR LETTERS BEFORE NOON

IWM PST 3623

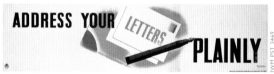

ADDRESS YOUR LETTERS PLAINLY

IWM PST 3469

post before lunch

IWM PST 3452

Catch the Noon Post

IWM PST 4035

Post much earlier this Christmas

IWM PST 3626

Send him Greetings on a Christmas Airgraph form

IWM PST 10034

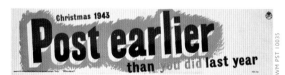

Christmas 1943 Post earlier than you did last year

IWM PST 10035

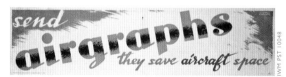

send airgraphs they save aircraft space

IWM PST 10048

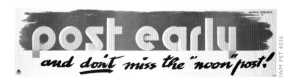

post early and don't miss the "noon" post!

IWM PST 4036

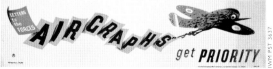

LETTERS to the FORCES AIRGRAPHS get PRIORITY

IWM PST 3637

The unusual shape of these posters hints at their function –
to adorn the mail vans of the General Post Office. They
provided a simple and effective means of reminding the
public of things they could do to benefit both the war
effort and the efficiency of the postal service.

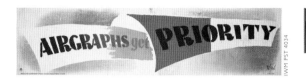

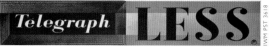

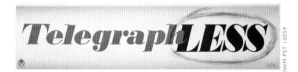

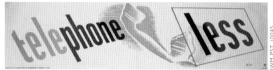

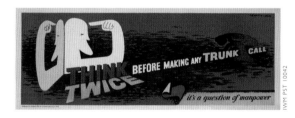

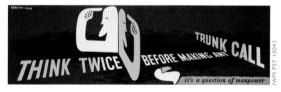

COLUMN 1: ERIC FRASER (1902–1983) POST EARLY AND DON'T MISS THE NOON POST (1941) / 'LEWITT-HIM' (L:1907–1991, H: 1900–1982) POST YOUR LETTERS BEFORE NOON (1941) / HANS SCHLEGER (ZÉRÓ) (1898–1976) POST BEFORE LUNCH (1941) / 'LEWITT-HIM' (L:1907–1991, H: 1900–1982) POST MUCH EARLIER THIS CHRISTMAS (1940) / LEONARD BEAUMONT (1891–1986) POST EARLIER THAN YOU DID LAST YEAR (1943) / AUSTIN COOPER (1890–1964) POST EARLY AND DON'T MISS THE NOON POST (1941) **COLUMN 2:** HANS SCHLEGER (ZÉRÓ) (1898–1976) ADDRESS YOUR LETTERS PLAINLY (1941) / TOM ECKERSLEY (1914–1997) ADDRESS YOUR LETTERS PLAINLY (1941) / HA ROTHHOLZ (1919–2001) CATCH THE NOON POST (1941) / AUSTIN COOPER (1890–1964) SEND HIM GREETINGS ON A CHRISTMAS AIRGRAPH FORM (1943) / AUSTIN COOPER (1890–1964) SEND AIRGRAPHS – THEY SAVE AIRCRAFT SPACE (1941) / 'LEWITT-HIM' (L: 1907–1991, H: 1900–1982) AIRGRAPHS GET PRIORITY (1943) **COLUMN 3:** HANS SCHLEGER (ZÉRÓ) (1898–1976) AIRGRAPHS GET PRIORITY (1943) / AUSTIN COOPER (1890–1964) TELEGRAPH LESS (1943) / MAURICE MAN (1921–1997) TELEGRAPH LESS (1943) / HANS SCHLEGER (ZÉRÓ) (1898–1976) TELEGRAPH LESS (1943) / UNKNOWN TELEGRAPH LESS (1943) / 'LEWITT-HIM' (L: 1907–1991, H: 1900–1982) THINK TWICE BEFORE MAKING ANY TRUNK CALL (1944) **COLUMN 4:** BARNETT FREEDMAN (1901–1958) TELEGRAPH LESS (1943) / HANS SCHLEGER (ZÉRÓ) (1898–1976) TELEPHONE LESS (1943) / BARNETT FREEDMAN (1901–1958) TELEPHONE LESS (1943) / HA ROTHHOLZ (1919–2001) TELEPHONE LINE TIME IS PRECIOUS (1942) / MAURICE MAN (1921–1997) BE BRIEF (1943) / 'LEWITT-HIM' (L: 1907–1991, H: 1900–1982) THINK TWICE BEFORE MAKING ANY TRUNK CALL (1944)

LEWITT-HIM

1900–1982
(GEORGE HIM)

1907–1991
(JAN LE WITT)

Jan Le Witt (left) and George Him working together in their Warsaw office during the mid 1930s

'Lewitt-Him' was a design and illustration partnership formed by the Polish-born artists, Jan Le Witt and George Him.

Initially, the artists had followed distinct career paths. Le Witt, born in Czestochowa to a Jewish family, was a self-taught painter who travelled around Europe attempting numerous jobs before settling on graphic art in 1928. Him, born to a Polish-Jewish family in Łódz, studied law and comparative religions prior to training as a graphic artist at the Leipzig Academy in Germany. However, after a meeting in Warsaw's famous Café Zemianska in 1933, the two artists decided upon a partnership, realising that their shared ideas would result in better work.

In Poland Lewitt-Him developed their characteristic style, blending surrealist and cubist tendencies with whimsical humour, most notably in illustrations for the *Skamander* experimental poetry group. In 1937 the duo moved to London after their work was exhibited by the publishers Lund Humphries. Advertising contracts from London Transport and Imperial Airways quickly followed.

During the Second World War Lewitt-Him continued to produce colourful and inventive posters for the Royal Society for the Prevention of Accidents, the General Post Office and the Ministry of Information. Their idiosyncratic interpretations of British home front initiatives proved highly popular – if not always understood. For example, their famous poster *Go by Shanks' Pony*, which encouraged people to walk short distances rather than use public transport, was thought by one observer to feature a pony wearing 'a handsome green cape'.

Besides creating posters, Lewitt-Him were also accomplished book illustrators. Their light-hearted and fanciful style translated perfectly into children's stories like *The Football's Revolt* (1939) and *The Little Red Engine Gets a Name* (1942) by Diana Ross. In 1954, the partnership dissolved after Le Witt decided to concentrate solely on painting. Him continued to work as a freelance designer and illustrator, famously creating the 'Schweppeshire' advertisements with the author Stephen Potter (1900–1969) for the drinks company Schweppes.

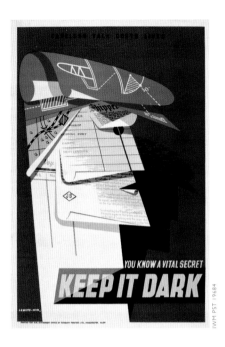

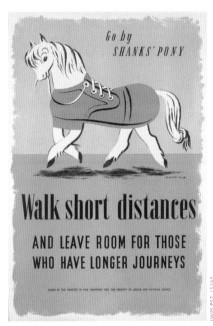

ALL **LEWITT-HIM**

KEEP IT DARK (1944)

GO BY SHANKS' PONY –
WALK SHORT DISTANCES
(1942)

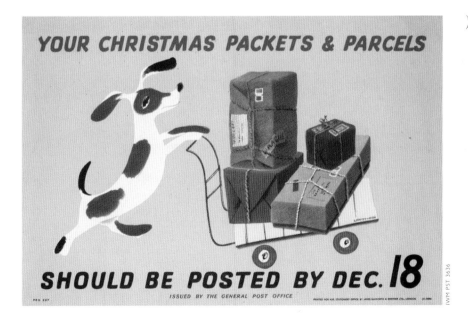

YOUR CHRISTMAS PACKETS
AND PARCELS (1941)

ABRAM GAMES
(1914–1996)
NIGHT AND DAY BRUSH
THE COBWEBS AWAY
(1945)

The need to maintain
the health and
well-being of an
entire population
at war undoubtedly
hastened the
institution of free
universal healthcare
in peacetime. Here
Abram Games
sought to remind
British troops of the
importance of good
oral hygiene. The
poster formed one
of a series initiated
by Games himself in
1941, which aimed
to encourage a range
of personal health
measures amongst
soldiers.

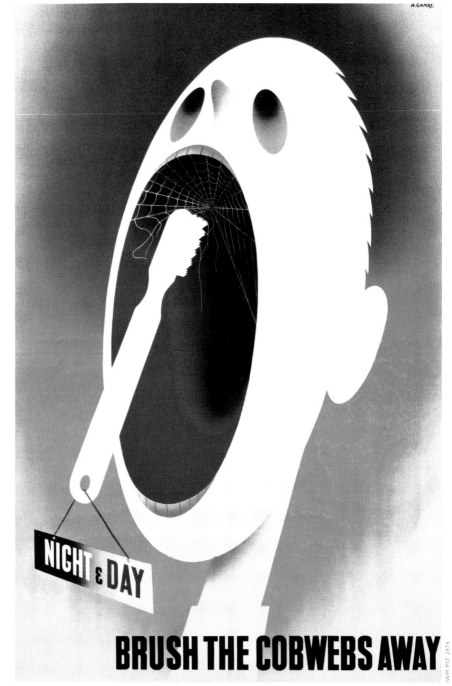

9. THE HEALTH OF THE NATION

BRITAIN'S WARTIME PUBLIC HEALTH CAMPAIGNS

The Ministry of Health (MOH) was founded in 1919, in the aftermath of the First World War, as a specific social welfare department. However, throughout the inter-war years healthcare in Britain remained dependent on the patient's ability to pay, and was administered via a decentralised mixture of local authorities and charitable hospitals. It was to be the Second World War which enforced dramatic change on Britain's health system – shifting the emphasis towards universal state provision, and leading eventually to the formation of the National Health Service in 1947.

Many wartime measures to safeguard public health served an immediate, pragmatic need, such as the MOH's 'Coughs and Sneezes Spread Diseases' campaign. This was introduced in 1942 to try and combat war production days lost to absenteeism. The MOH mounted its own publicity for the campaign, which was made memorable by the humorous posters of the cartoonist H M Bateman (1887–1970) (see page 69).

Other health initiatives – such as the diphtheria child immunisation scheme launched in late 1940 – demonstrated a commitment to broader, ongoing social concerns. Long associated with overcrowding and slum conditions, diphtheria had until then claimed around four thousand lives a year, its victims mainly children. Once more the MOH managed its own publicity for the scheme, which ran until 1944. The most notable

posters of the campaign were by Reginald Mount (1906–1979), a versatile designer who had been employed by the Ministry of Information since 1939, creating the famous 'Firebomb Fritz' character to warn of German incendiary bombs. In 1943 Mount created two distinct posters for the MOH. The first, *Diphtheria is a Killer* – a rather sentimental and unadventurous illustration of a vulnerable infant – betrayed Mount's pre-war commercial work for the advertising agencies Greenlys and Lintas. This poster was superseded by the more aggressive *Diphtheria Costs Lives*. Here the dramatic use of photomontage, indebted to Soviet Constructivism and the Republican propaganda of the Spanish Civil War, was intended to inject greater urgency into the inoculation campaign.

These posters, alongside Mount's three designs for the MOH's 1943–44 venereal disease awareness campaign (page 70–71), reveal a growing sense of obligation in government to shape public behaviour in personal health matters. They show the makings of a new 'state paternalism' in wartime that lasted until the late 1970s. During this later period public health publicity fell largely to the Ministry of Information's successor, the Central Office of Information (COI). Mount for his part remained closely involved in post-war health initiatives; most notably the COI's anti-smoking and road safety campaigns of the 1960s.

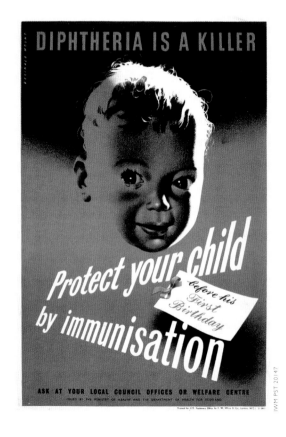

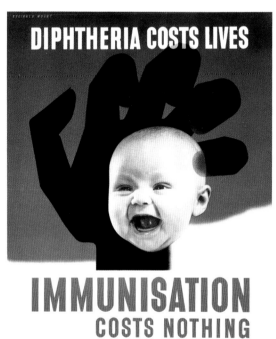

In a bid to raise awareness of the diphtheria threat to children, Mount sought inspiration from 1920s Soviet Constructivist photomontage and the disturbing iconography of Sergei Eisenstein's groundbreaking 1925 propaganda film, *The Battleship Potemkin*. The resulting design embodied the new age of social welfare emerging in wartime Britain that would help define the political landscape for the next thirty years.

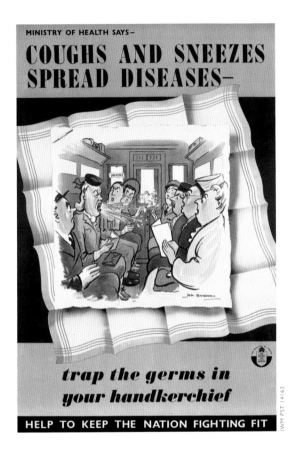

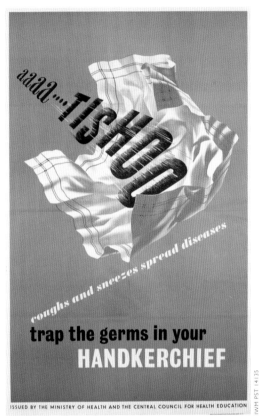

Renowned for his comic depictions of social gaffes and misdemeanours (appearing in magazines such as *Tatler*), Bateman produced a series of eight posters for the 'Coughs and Sneezes' campaign. Each depicted a different scenario showing the spread of germs by careless and inconsiderate behaviour.

Wartime Ministry of Health initiatives to prevent the spread of germs continued into peacetime. This reflected an increased government responsibility for public health as well as the need to maintain optimum production levels in Britain's faltering post-war economy.

REGINALD MOUNT
(1906–1979)
VD – HELLO BOY-FRIEND,
COMING MY WAY?
(1943)

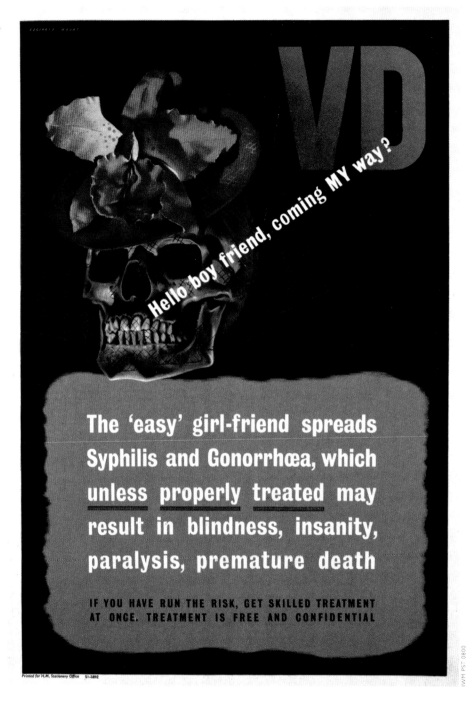

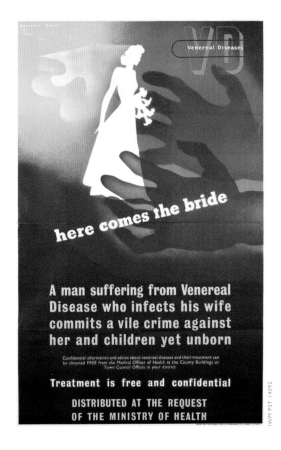

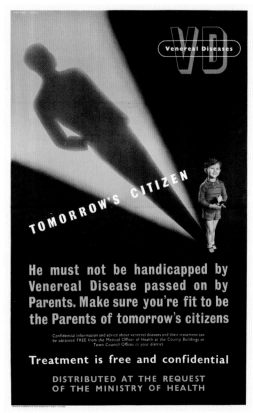

Produced for the Ministry of Health in 1943 to tackle a huge
increase in cases of venereal disease, Mount's three posters
reveal a shift in emphasis – from conditioning servicemen
into near misogynistic suspicion of potential female disease-
carriers, to urging greater social responsibility in sexual
habits. The implicit message: if Britain was to enjoy better
standards of health, then it was as much down to the
individual as it was to the state.

DONIA **NACHSHEN**

B. 1903 –
ACTIVE 1940s

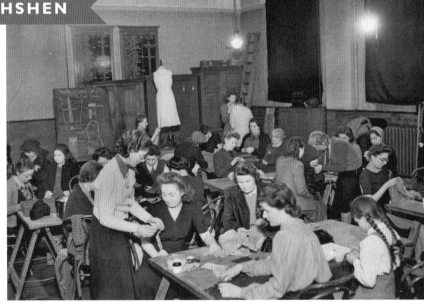

Mend and Make Do:
An original Ministry
of Information photo,
showing a dressmaking
class in Brixton, 1943

IWM D 12896

Donia Esther Nachshen was
born on 22 January 1903 into
a Jewish family in Zhitomir in
Russian Poland. Following anti-
Jewish pogroms [riots] in the
city, Nachshen moved with her
family to London in 1906 and
later studied at the Slade School
of Art. In the 1920s Nachshen
established a career as a book
illustrator, deriving a style from
Art Deco and Russian folk art to
illustrate translations of works
by Anatole France and Arthur
Schnitzler. She also illustrated
an English language version of
the Jewish religious text, *The
Haggadah* in 1934.

During the Second World War
Nachshen created several loosely
drawn posters for the Board of
Trade's 'Make Do and Mend'
campaign, as well as more detailed
designs for the General Post Office
in 1943. Nachshen also continued
to illustrate books in wartime,
producing dramatic monochrome
images to accompany versions of
Nikolai Gogol's *Diary of a Madman*
and Feodor Dostoyevsky's *Three
Tales* in 1945. Nachshen lived and
worked in Hendon in London after
the war, illustrating mainly works
of Russian literature and poetry for
the publishers Lindsay Drummond
and Constable & Co.

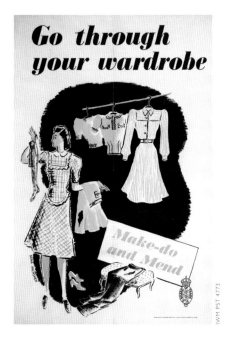

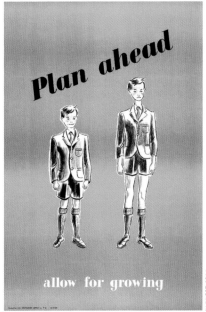

ALL **DONIA NACHSHEN**
(B.1903–ACTIVE 1940s)

GO THROUGH YOUR
WARDROBE – MAKE DO
AND MEND (1942)

PLAN AHEAD – ALLOW
FOR GROWING (1942)

IWM PST 4773

IWM PST 8564

TELEGRAPH LESS (1943)

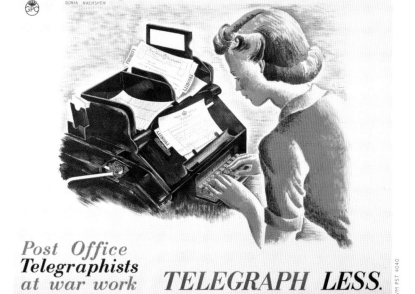

IWM PST 4040

Produced only
one month into
his job at the War
Office, Games
had intended this
poster to improve
the drab image
of the Auxiliary
Territorial Service
(ATS). However, his
touch of Hollywood
glamour was
considered a step too
far. It was replaced
by a more prosaic
effort, *You Are
Wanted Too! – Join
the ATS*, featuring
a photograph of a
serving ATS Private.

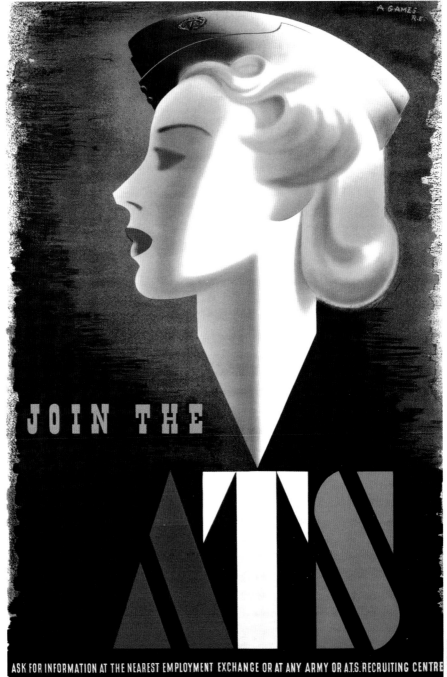

JOIN THE

ATS

ASK FOR INFORMATION AT THE NEAREST EMPLOYMENT EXCHANGE OR AT ANY ARMY OR A.T.S. RECRUITING CENTRE

10. WORTH FIGHTING FOR?

CHURCHILL, CONTROVERSY AND CENSORSHIP

Despite an insistence that the war was being fought to safeguard democracy and personal liberty, Churchill throughout remained sensitive to any expression which he perceived to be detrimental to morale. An obvious instance of this sensitivity was his attempt to prevent the release in 1943 of the film *The Life and Death of Colonel Blimp*, which satirised the British officer class.

Churchill's attitude towards British poster propaganda was no different. In 1941 Abram Games (1914–1996) inadvertently courted controversy with his notorious Auxiliary Territorial Service (ATS) recruitment poster, nicknamed the 'blonde bombshell' (opposite). Deemed too risqué for impressionable young recruits, it was withdrawn only for Churchill to object to its follow-up design on the grounds of its 'Soviet' overtones.

Games and Churchill's paths crossed again in 1943, but this time over a more serious issue. From 1941, with the threat of invasion receding, the thoughts of many in Britain turned to life after the war. The Ministry of Information recognised that ideas of post-war reform helped boost morale, but Churchill, nervous that such talk would cause public opinion to shift to the Left, decreed otherwise.

Other organisations however actively encouraged long-term aspirations. Formed in 1941, the Army Bureau of Current Affairs (ABCA) was an educational body committed to promoting debate within the 'citizen army' on diverse matters

such as reconstruction and international relations. In 1942, ABCA approached Games to create posters to stimulate debate on the ideological basis of Britain's war effort. Assisted by the respected poster artist, Frank Newbould (1887–1951), Games produced the series *Your Britain – Fight for It Now*. This series offered two markedly different images of the Britain that was being fought for. Whereas Newbould's posters presented a nostalgic hymn to English rural and ecclesiastical traditions (overleaf) Games's vision was unashamedly progressive and metropolitan. Reflecting a belief in the power of Modernist architecture to deliver both physical and social renewal, Games's posters pictured existing Modernist civic structures as signifiers of future change, each superseding scenes of urban decay and deprivation (see pages 78–79).

Although all of these posters featured in the *Poster Design in Wartime Britain* exhibition at Harrods in 1943, the design that commanded Churchill's greatest attention, and ire, was the image of the Berthold Lubetkin-designed Finsbury Health Centre. Intended to represent universal healthcare triumphing over disease – symbolised by a rickets-afflicted child – the image was interpreted by Chuchill as 'a disgraceful libel on the conditions prevailing in Great Britain before the war [...] The soldiers know their homes are not like that'. Enraged by this 'distorted propaganda' he demanded the poster be withdrawn forthwith.

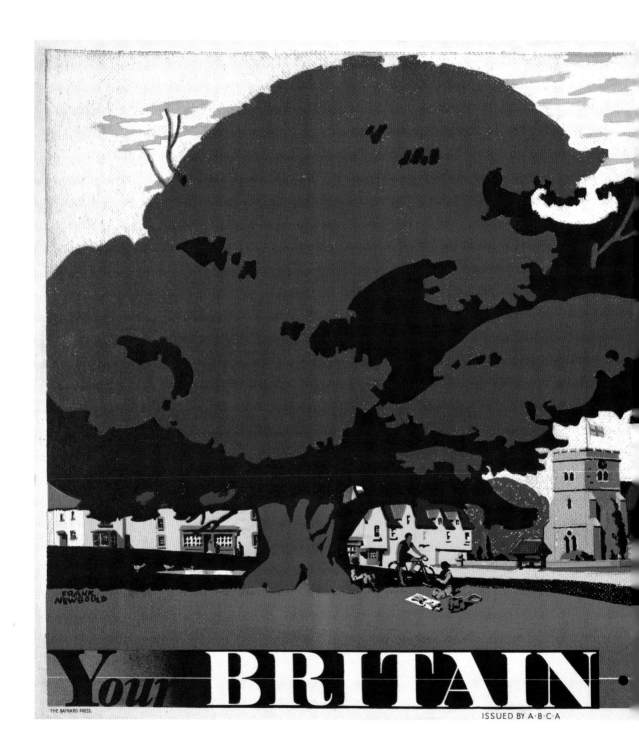

DESIGNED BY P.R.2. 71

IWM PST 3641

ALL **FRANK NEWBOULD** (1887–1951)

YOUR BRITAIN – FIGHT FOR IT NOW (1942)

YOUR BRITAIN – FIGHT FOR IT NOW
(SALISBURY CATHEDRAL) (1942)

YOUR BRITAIN – FIGHT FOR IT NOW
(THE SOUTH DOWNS) (1942)

Newbould established his name during the
1920s and 30s creating tourism posters for rail
companies such as Great Western Railways.
Yet despite this successful pre-war career, and
being the older designer, Newbould worked
under Games at the War Office. Newbould's
Your Britain series, both stylistically and in
subject matter, owed much to his earlier travel
posters; essentially picturing a tourist's vision
of an England worth fighting for.

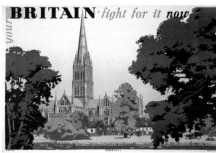

IWM PST 3640

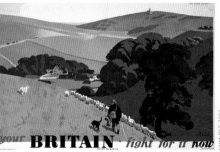

IWM PST 2802

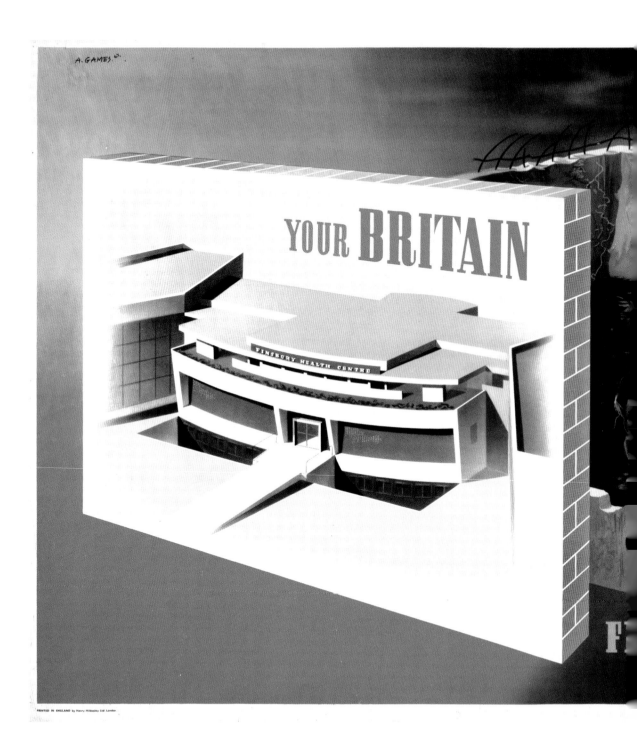

A. GAMES.

YOUR BRITAIN

FINSBURY HEALTH CENTRE

Modern medicine means
the maintenance of good
health and the prevention
and early detection of
disease. This is achieved
by periodic medical
examination at Centres
such as the new Finsbury
Health Centre, where
modern methods are used.

ISSUED BY A.B.C.A.
DESIGNED BY P.R.2. 80.

IWM PST 2911

ALL **ABRAM GAMES** (1914–1996)

YOUR BRITAIN – FIGHT FOR IT NOW
(FINSBURY HEALTH CENTRE) (1942)

YOUR BRITAIN – FIGHT FOR IT NOW
(KENSAL HOUSE) (1942)

YOUR BRITAIN – FIGHT FOR IT NOW
(IMPINGTON VILLAGE COLLEGE, CAMBRIDGE) (1942)

Games pictured key modernist social
architecture to stress a new post-war
society's commitment to tackling the social
ills of ignorance, disease and squalor.
Exhibited at the *Poster Design in Wartime
Britain* show in 1943, the Finsbury Health
Centre poster (main image) was deemed
by Churchill and Ernest Bevin to be critical
of pre-war social conditions, and Churchill
ordered its removal. Nevertheless the
remaining two posters – featuring Maxwell
Fry and Walter Gropius's Impington Village
College, Cambridge and Fry and Elizabeth
Denby's Kensal House in Ladbroke Grove –
were permitted to stay on view.

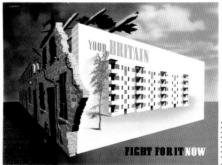

IWM PST 2909

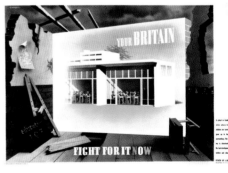

IWM PST 2907

ABRAM GAMES (1914–1996)
SERVE AS SOLDIER VOTE
AS A CITIZEN (1944)

Like Games, many in
Britain's armed forces
felt that sacrifices made
in wartime warranted
a fairer, more equal
society in peacetime.
In this poster Games
urged the Forces
to effect change via
the ballot box. An
estimated 80 per cent
of serving men and
women helped
deliver the 1945
Labour landslide
election victory.

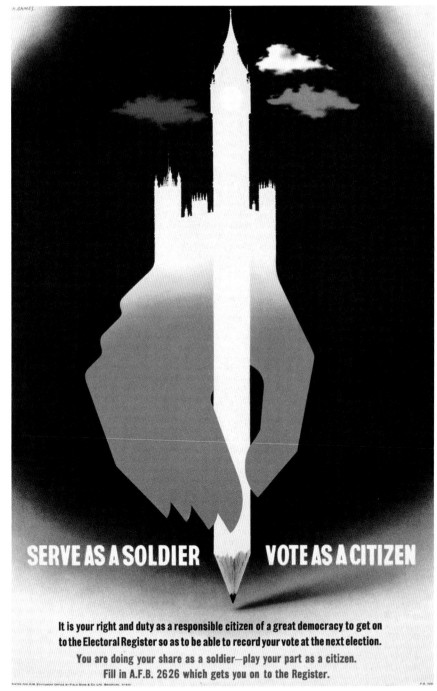

SERVE AS A SOLDIER VOTE AS A CITIZEN

It is your right and duty as a responsible citizen of a great democracy to get on
to the Electoral Register so as to be able to record your vote at the next election.
You are doing your share as a soldier—play your part as a citizen.
Fill in A.F.B. 2626 which gets you on to the Register.

II. VISIONS OF A NEW JERUSALEM

POSTERS OF THE POST-WAR

For Britain's population, the Second World War meant 'total war'. The lives of everyone, regardless of wealth or social standing, were affected. This shared experience gave rise to a sense of a 'people's war'. Moreover, rationing, public health programmes and the demand for labour had brought about hitherto unseen levels of social equality and democracy in Britain. There existed a kind of organic socialism, not shaped by any political doctrine, but based more on time-honoured British ideals of 'fair shares' and 'common decency'.

Hopes for a newer, more equal post-war society were a sustaining force during the long, arduous conflict. Posters promoting savings schemes further encouraged the public to dream of a new affluent society built on independent finances and technological advancement. Such dreams appeared almost realised with the publication of the Beveridge Report in 1942, which promised a peacetime Welfare State to eradicate society's five 'giant evils' of squalor, ignorance, want, idleness and disease.

The wish never to return to pre-war class divisions and poverty was most keenly felt within Britain's armed forces. With Allied victory assured, the enlightened Army Education Scheme fuelled the peacetime aspirations of the rank and file by offering access to the arts and sciences besides vocational training. These hopes found expression in the decisive role of the services'

vote in delivering the Labour landslide electoral victory of 1945.

Clement Attlee's Labour Party immediately began implementing the Beveridge Report, passing both the National Insurance Act and the National Health Act in 1946. They also introduced a programme of public-ownership, nationalising the coal industry in 1947 and then the steel industry in 1948. Facing an acute shortage of housing, short-term remedies had already been explored in wartime with exhibitions highlighting America's use of prefabricated homes during the Depression. Soon similar 'prefabs' were appearing across Britain, with over 125,000 built by 1948.

Despite this positive start, reconstruction and vigorous Labour reform proved highly expensive, especially for a country bankrupted by war. By 1947 the national situation was particularly perilous. With most overseas assets sold to pay for war, Britain was in debt by over £600 million and facing a widening trade gap with the United States. The desperately cold winter of 1946–47 caused further hardship, forcing the rationing of potatoes. Thus the euphoria of Allied victory gave way to a long period of 'austerity' that would reduce Labour's radical social agenda, and from which Britain would not emerge until the 1950s.

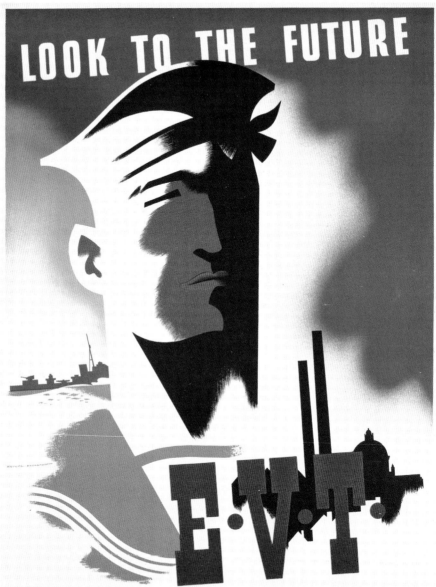

LOOK TO THE FUTURE

E·V·T

EDUCATIONAL & VOCATIONAL TRAINING

ASK YOUR EDUCATION OFFICER

IWM PST 14648

ABRAM GAMES (1914–1996)
ARMY EDUCATION SCHEME
(1945) (x4)

Games sympathised with the aspirations of many in Britain's 'citizen army' for social betterment and personal fulfilment following Allied victory. In his four posters promoting the Army Education Scheme, he advocated education for the ranks as the means of success in a new meritocratic post-war Britain.

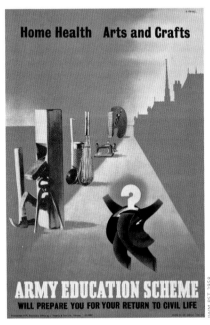

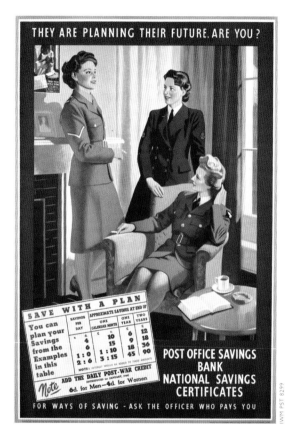

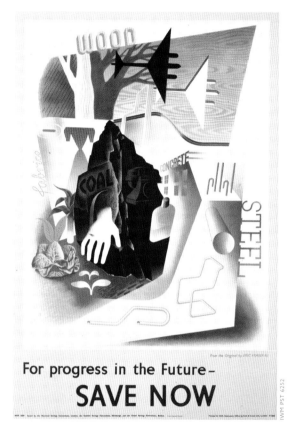

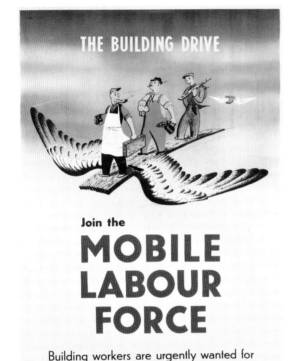

During the 1930s, United States Government agencies like the Tennessee Valley Authority pioneered the use of prefabricated dwellings to house their workforces. The *American Housing in War and Peace* exhibition of July 1944, sponsored by the Royal Institute of British Architects and the US Office of War Information, showed how temporary and easily constructed homes could be a solution to Britain's housing shortage. Although intended only as short-term accommodation, many 'prefabs' still remain inhabited today.

The Polish Resettlement Corps (PRC) was established by the
British Army in 1946 to help integrate into British society Free
Polish servicemen not wishing to return to their Soviet-dominated
homeland. The poster created by Dekk, herself a Czech-born
émigré, offered work in vital industries in Britain.

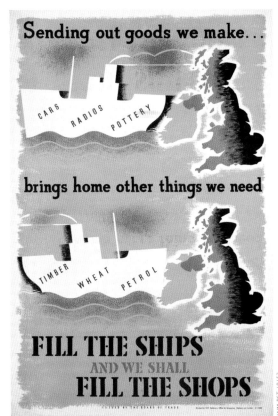

In peacetime a different kind of recruitment poster announced the Labour government's nationalisation of the coal industry in 1947. Though not providing drastic increases in wages, nationalisation at least improved working conditions and safety measures for many miners, and fulfilled Labour's promise of public ownership.

At the end of the war Britain faced severe shortages of raw materials and grew increasingly reliant on American imports, causing a huge trade deficit. Posters such as this, reminiscent of wartime production drives, urged greater productivity in industry to help pay for imports. But depleted British industries could do little to compete with the economic might of the United States.

Vividly-coloured
National Savings
posters of American-
inspired suburban
families helped
finance the war
effort by promising
aspiring British
savers affluence
and stability once
war was over. The
post-war reality was
somewhat different,
with Britain
enduring many grey
years of austerity
until the more
prosperous 1950s.

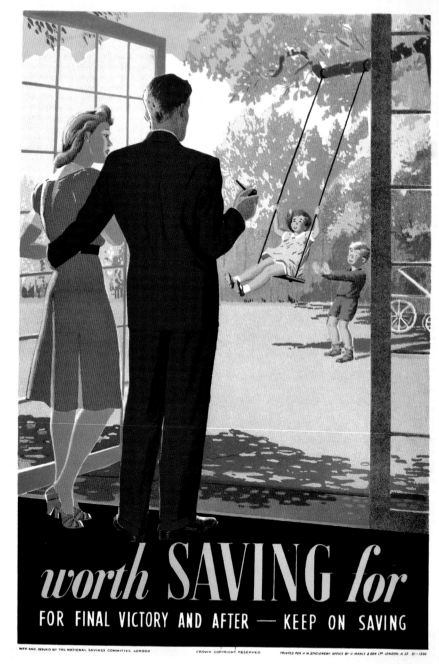

worth SAVING *for*

FOR FINAL VICTORY AND AFTER — KEEP ON SAVING

WFP 440. ISSUED BY THE NATIONAL SAVINGS COMMITTEE, LONDON CROWN COPYRIGHT RESERVED PRINTED FOR H.M.STATIONERY OFFICE BY H.MANLY & SON LTP LONDON, N.22 61·-1333

IWM PST 21067